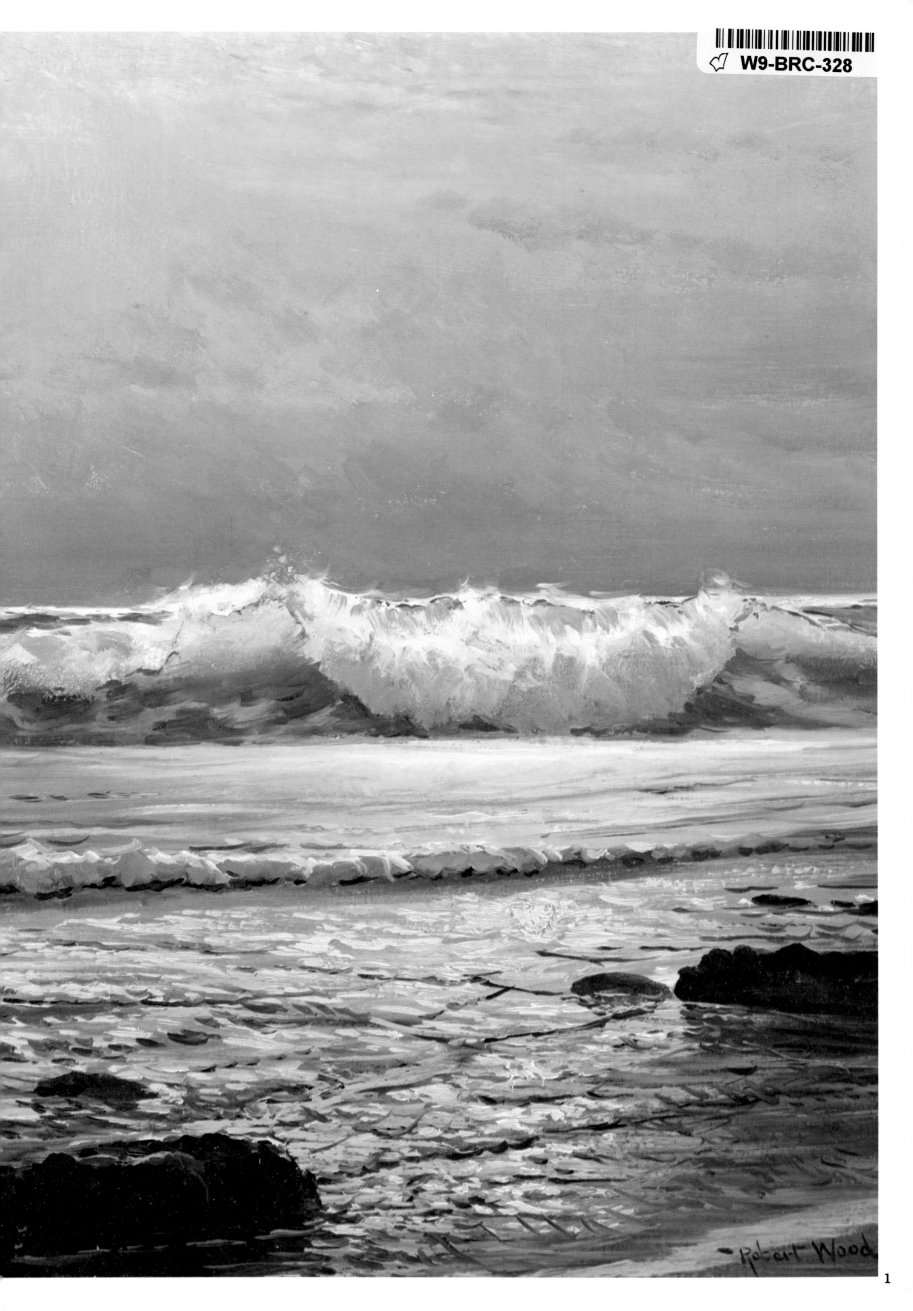

Robert Wood

ANSWERS TO A FEW QUESTIONS
FROM STUDENTS

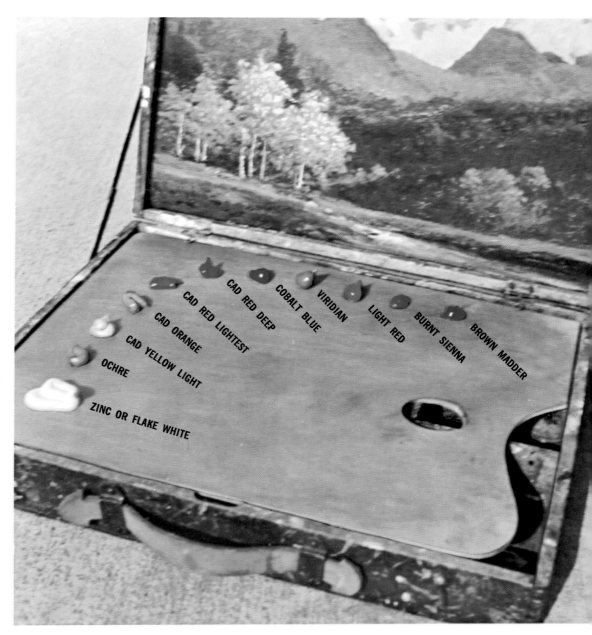

Plain, simple wording is used throughout this book to avoid confusing the person searching for the best method to paint a picture. Have a definite purpose in mind and then proceed to lay out your painting. Have your horizon more or less above or below center, never in the middle.

Grey your tints down on the canvas by first going over the different areas with the opposite colors, using the same values. (If you do not understand, see color charts in "Oil Painting" or "Mixing Colors.") You never see pure color in nature. Make your brush strokes follow contours of hills, etc. or anything you are painting. Paint thick or thin to please your own whim. Safest way is to do your painting in one sitting. However, you can get good results by finishing a picture after the lay-in has dried, and rubbing an oily rag over the dry work before applying second coat. Art is full of accidental effects.

When a pleasing accident appears, leave it alone. It will never return. Have a hot spot or one point of interest, center it, but not right in the middle.

You may cook up pictures to your heart's content in your studio. But do try to paint from nature as much as possible. Spend no longer than one hour on a painting; outdoor shadows change too much after that.

Get all the important lines, lights and shadows at the same hour the next day or so, or complete your masterpiece at home. I do not leave paint rags lying around after painting. Always clean up before leaving a location. Think of the one coming next, or the owner that may stop ALL from painting there.

You men painters, if you use a sketch box, slip your belt through the handle and fasten. It helps to hold the outfit and free your hands. Sure, you ladies can take a belt along, why not?

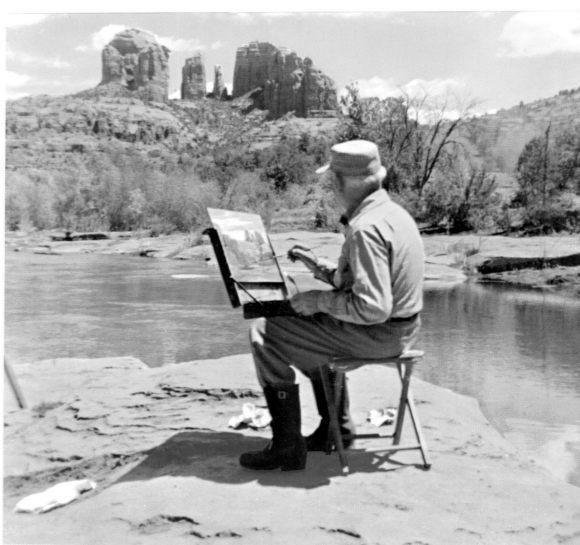

If you are painting out in the sun, it is best to have an umbrella. You are apt to become so absorbed in your work that you will not notice the heat, so play it safe; we want you around for a long, long time. Remember, do not take your painting too seriously or yourself, for that matter. Yes, have fun.

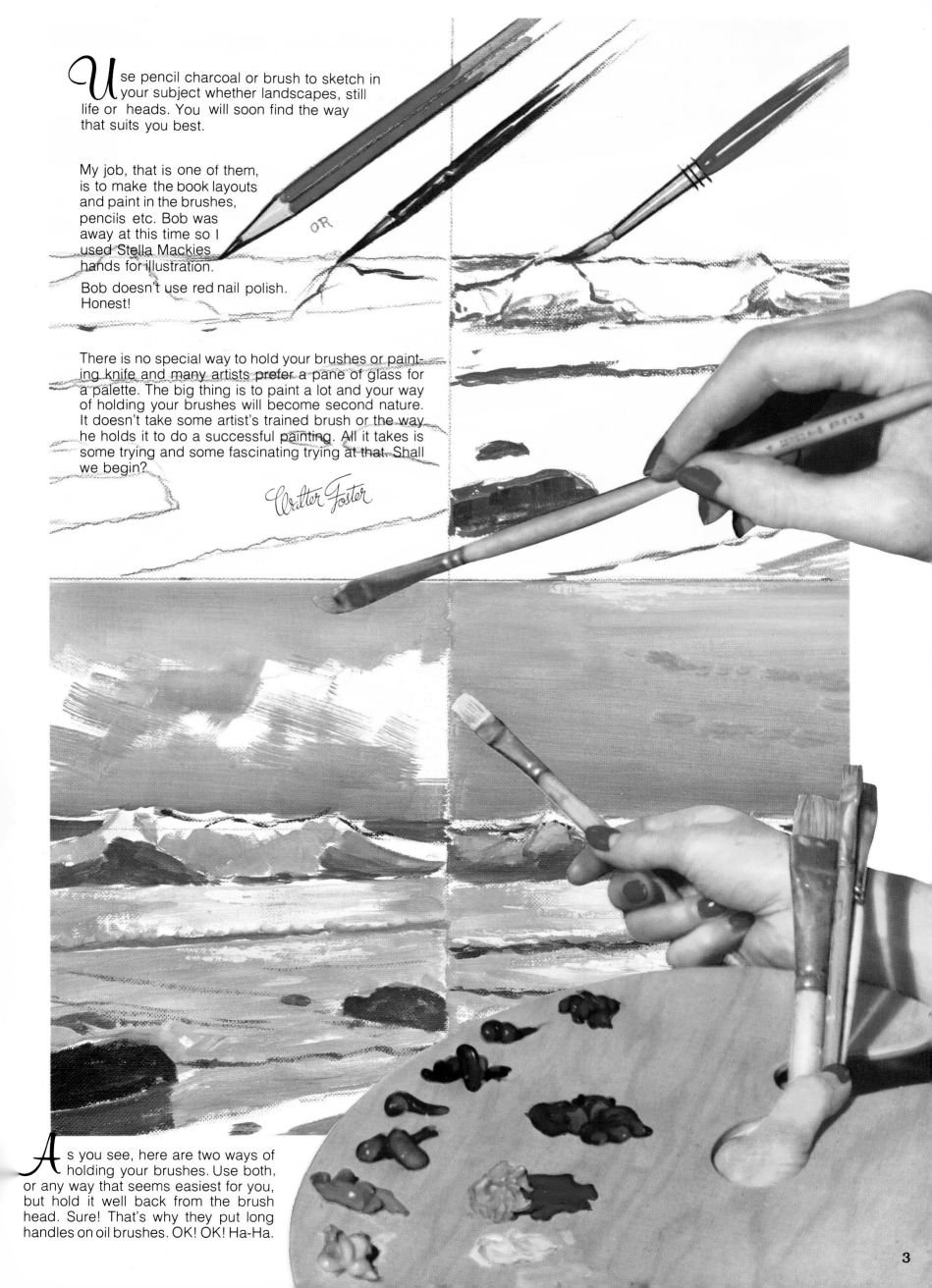

Use pencil charcoal or brush to sketch in your subject whether landscapes, still life or heads. You will soon find the way that suits you best.

My job, that is one of them, is to make the book layouts and paint in the brushes, pencils etc. Bob was away at this time so I used Stella Mackies hands for illustration.

Bob doesn't use red nail polish. Honest!

There is no special way to hold your brushes or painting knife and many artists prefer a pane of glass for a palette. The big thing is to paint a lot and your way of holding your brushes will become second nature. It doesn't take some artist's trained brush or the way he holds it to do a successful painting. All it takes is some trying and some fascinating trying at that. Shall we begin?

Walter Foster

As you see, here are two ways of holding your brushes. Use both, or any way that seems easiest for you, but hold it well back from the brush head. Sure! That's why they put long handles on oil brushes. OK! OK! Ha-Ha.

OR

3

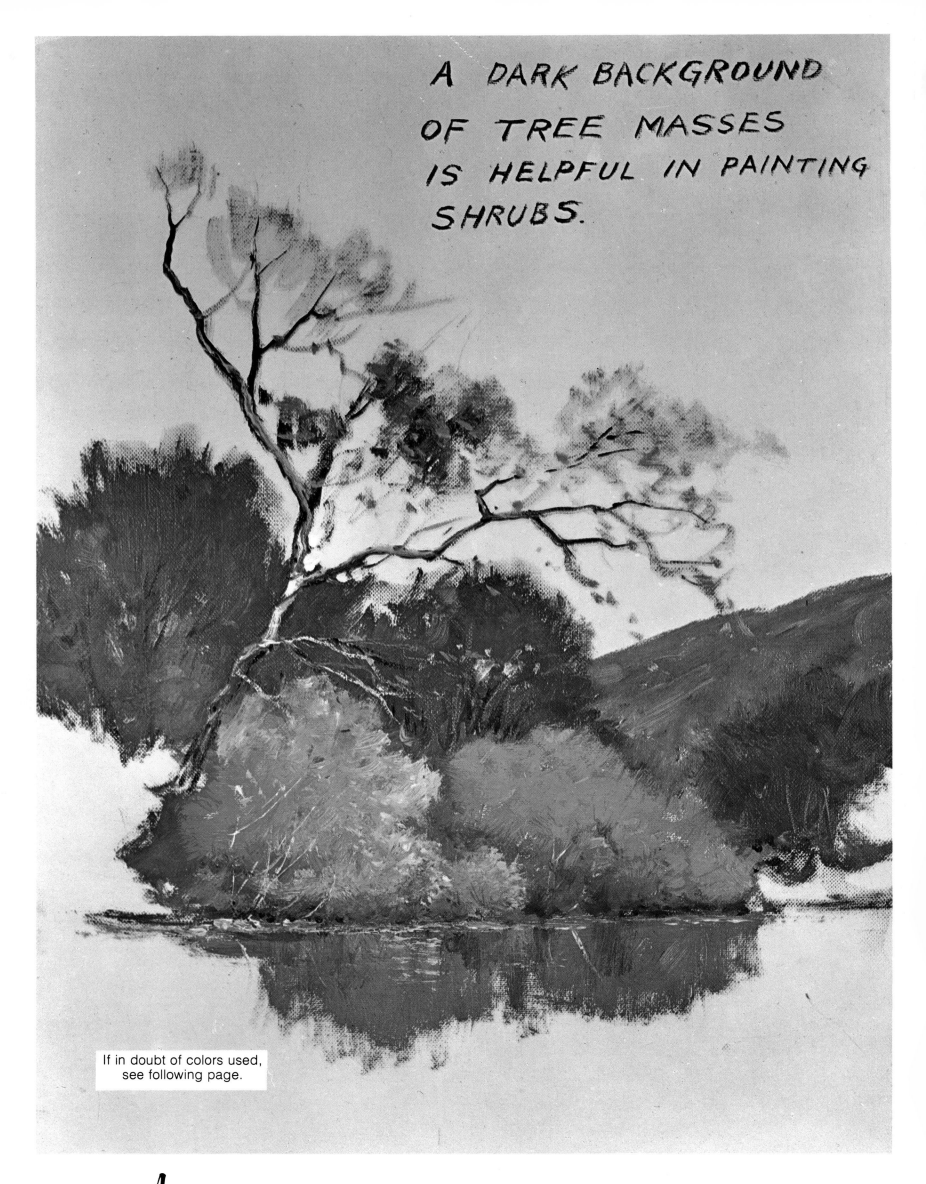

A DARK BACKGROUND
OF TREE MASSES
IS HELPFUL IN PAINTING
SHRUBS.

If in doubt of colors used,
see following page.

\mathcal{A} quick sketchy wash-in, using thin paint, merely to guide you with composition and color. As you proceed, lay the heavier pigment and keep piling it on until you finish your masterpiece. As you can see, this canvas is quite coarse. Remember, you cannot get this effect on a smooth surface.

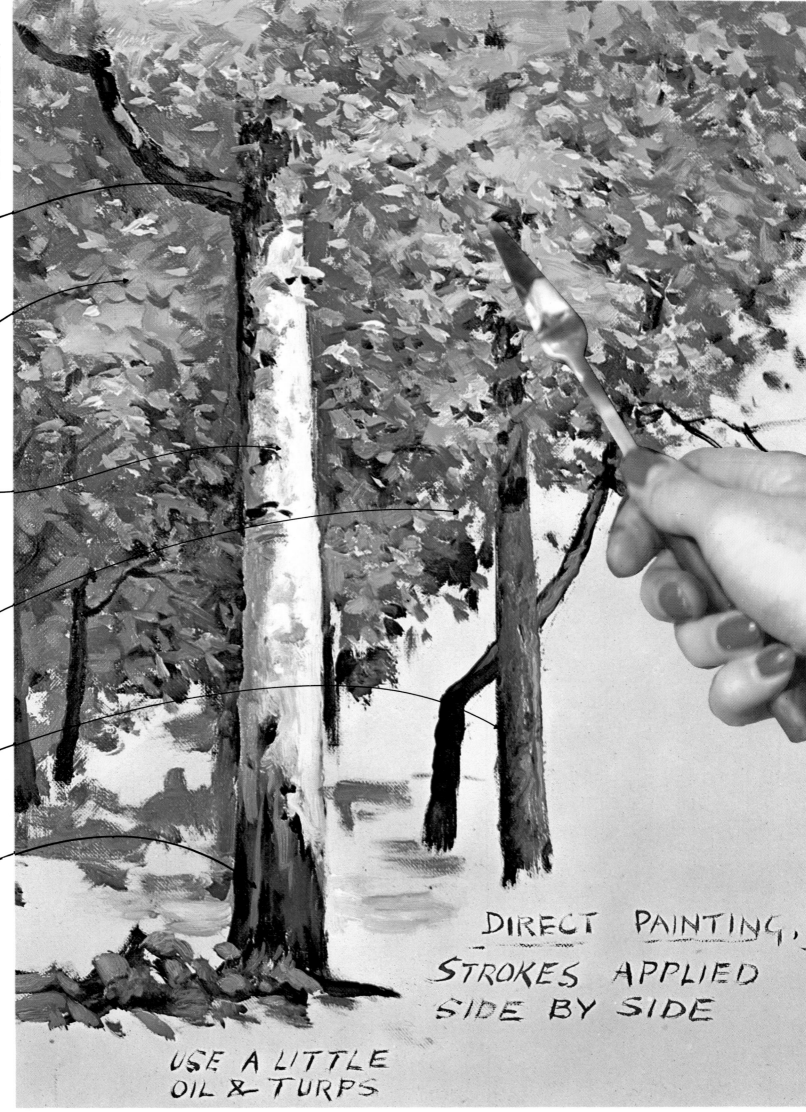

When you try working with a paint-knife or palette knife, play around Red, Yellow, Blue White—no other or. You will learn ch and I know you be surprised at the at variety of colors will get. Sure, try same thing if you to use a brush.

rown Madder on limb

Ochre, Red and White

light bark, add hite to Ochre and Red

chre, Red and te if you want it lighter

hre, Red and a ouch of Blue

Ochre, Red and more Blue for darks

DIRECT PAINTING,
STROKES APPLIED
SIDE BY SIDE

USE A LITTLE
OIL & TURPS

You would see very little sky in the tree masses. Form whatever sky you need around and between the leaves until you get a pleasing pattern. Punch a few holes among the foliage to open up the density. Until you make many drawings and paintings of trees and shrubs, you will have trouble getting the professional touch in your paintings. There are a number of good books on trees and shrubs. Make many drawings from them so you can remember what they really look like.

This is the way Mr. Robert Wood starts and finishes a painting. The first panel is a good example of a quick pencil sketch, using an HB or 4B pencil or charcoal, for placement purposes only. The second panel illustrates the importance of placing a Cobalt Blue wash over the pencil sketch to deter the lines from smearing.

I know you will enjoy this book and hope it fills in many happy and carefree hours for you.

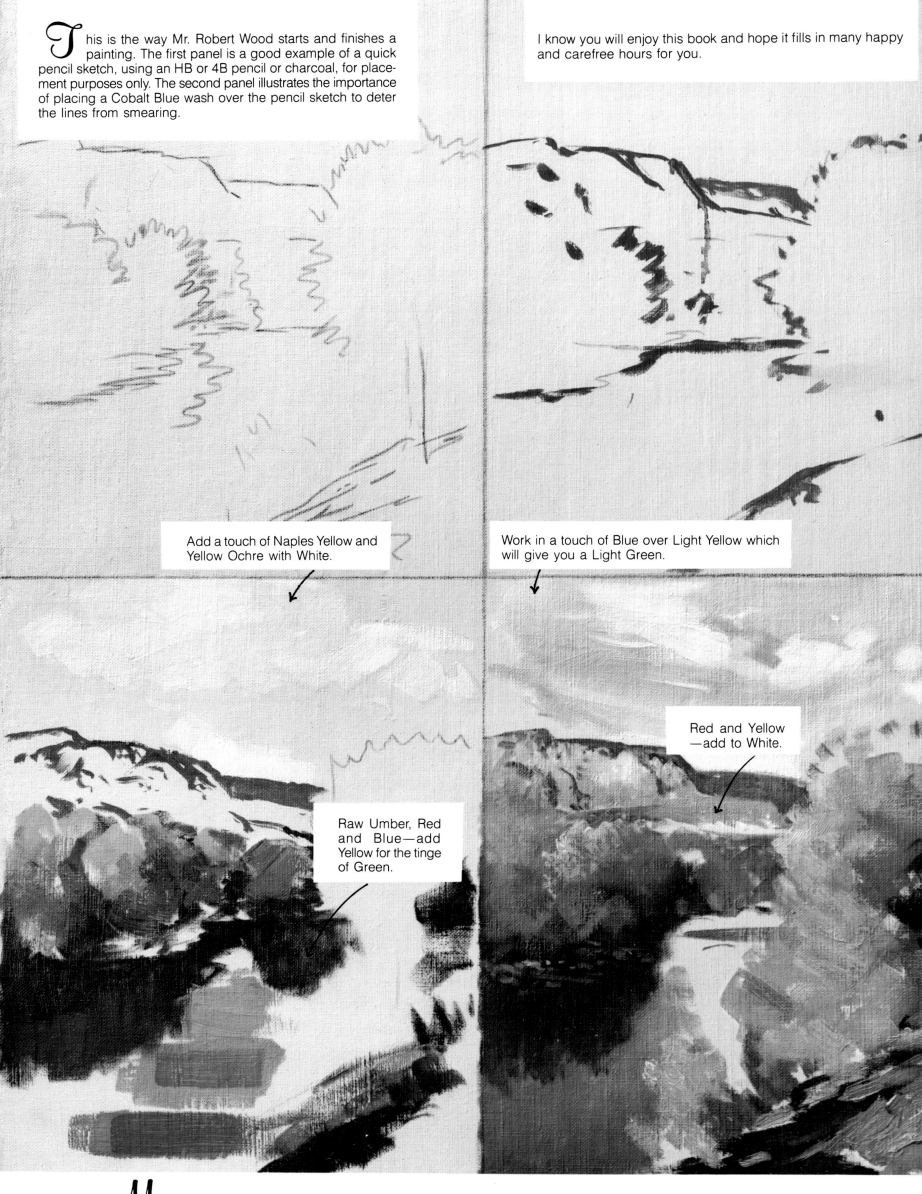

Add a touch of Naples Yellow and Yellow Ochre with White.

Work in a touch of Blue over Light Yellow which will give you a Light Green.

Raw Umber, Red and Blue—add Yellow for the tinge of Green.

Red and Yellow —add to White.

Mr. Wood is one of our very successful painters and an in-depth study of his work should aid you tremendously in your own growth as an artist. Several of his seascapes and landscapes are in our other books, such as "How To Draw And Paint Seascapes".

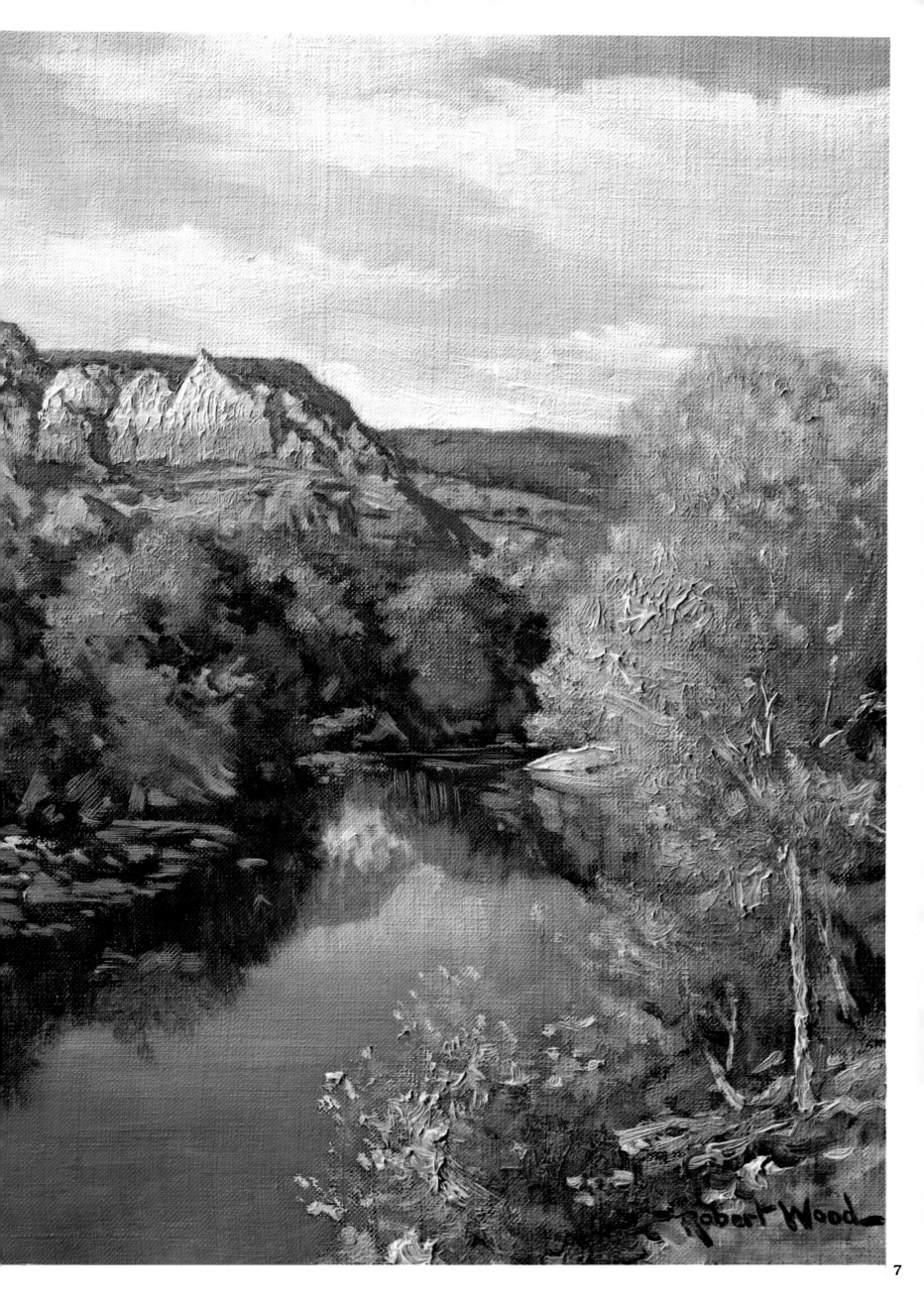

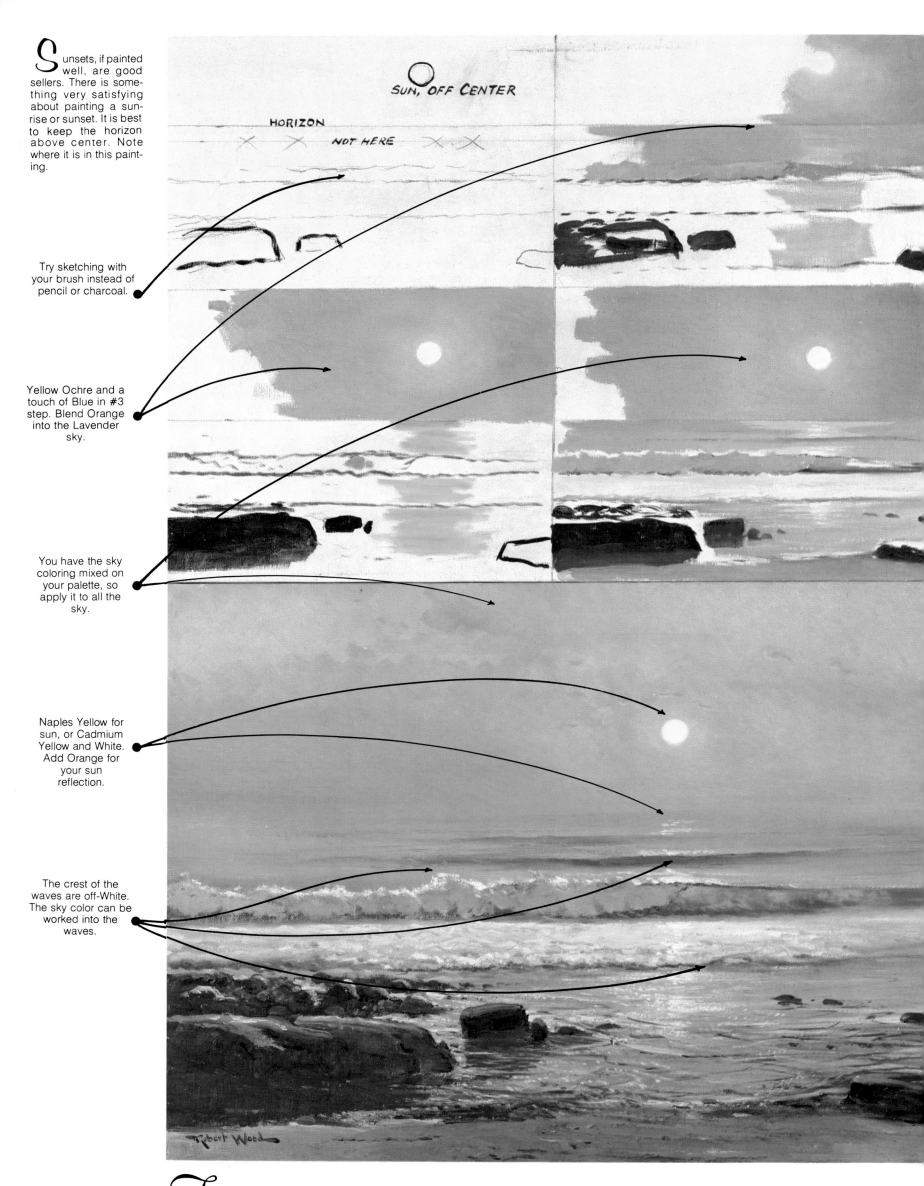

Sunsets, if painted well, are good sellers. There is something very satisfying about painting a sunrise or sunset. It is best to keep the horizon above center. Note where it is in this painting.

Try sketching with your brush instead of pencil or charcoal.

Yellow Ochre and a touch of Blue in #3 step. Blend Orange into the Lavender sky.

You have the sky coloring mixed on your palette, so apply it to all the sky.

Naples Yellow for sun, or Cadmium Yellow and White. Add Orange for your sun reflection.

The crest of the waves are off-White. The sky color can be worked into the waves.

SUN, OFF CENTER

HORIZON

NOT HERE

This seascape of the lowering sun was painted direct, with no need for the Blue outline. Simply lay your heavy pigment on and model it with the brush until you have the desired effect. Spread a little pale Yellow with a palette knife for the sun, then cut around in a circle, using greyed Yellow. There you have the spherical form! Deepen your sky color as you work away from the brilliant spot. I saw this lovely scene while strolling along Laguna Beach and thought it would be enjoyed by painters everywhere.

8

First make a drawing of the Rock subject in pencil or charcoal. Then go over it with a thin Blue outline wash. Finish with colors straight from tubes.

It is much wiser to do a simple painting well than a difficult painting poorly. It is so easy to over-step our ability and blame the lack of success on ourselves. Patience and common sense is a fine pattern to follow in all walks of life.

HB or 4B Pencil

Outline with Blue

Cadmium Red, Cobalt Blue, mostly White

Same as the above only leave out the White

light Cobalt Blue over the warm base color (see above)

Add Yellow Ochre to your Cadmium Red and Cobalt Blue

Add Yellow Ochre to Light Blue

Painting knife or palette knife are good for rocks. Try for broad strokes. Pick up a few rough rocks around your house. They make good models, as a ¼ lb. rock can be the model for a 50 ton rock in your picture. Make many pencil drawings and oil sketches of these rocks in many positions. This you will find very valuable and time well spent. Just remember that anyone can accomplish a well-rounded life and a certain success if they have sufficient desire.

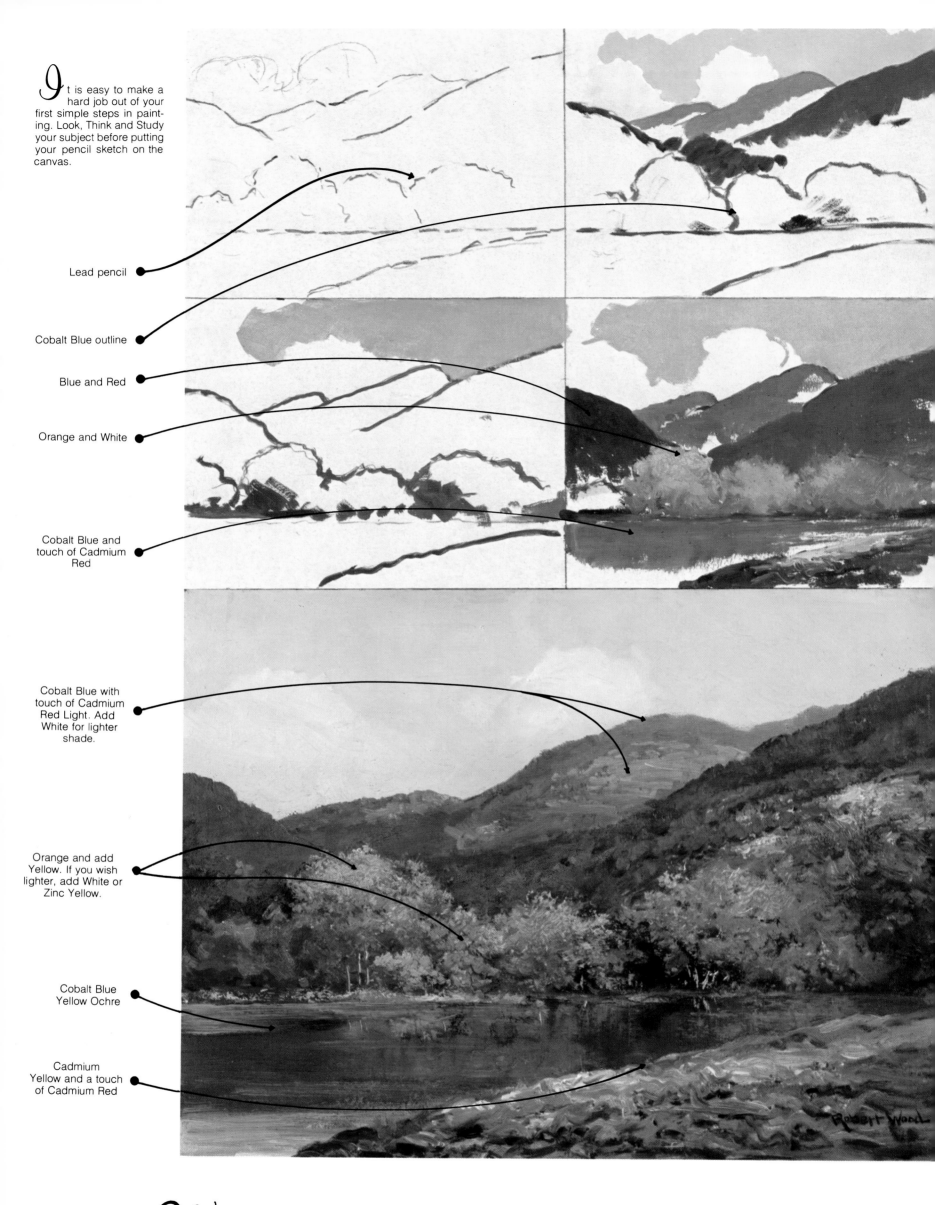

It is easy to make a hard job out of your first simple steps in painting. Look, Think and Study your subject before putting your pencil sketch on the canvas.

Lead pencil

Cobalt Blue outline

Blue and Red

Orange and White

Cobalt Blue and touch of Cadmium Red

Cobalt Blue with touch of Cadmium Red Light. Add White for lighter shade.

Orange and add Yellow. If you wish lighter, add White or Zinc Yellow.

Cobalt Blue Yellow Ochre

Cadmium Yellow and a touch of Cadmium Red

When I explain the beauty spots in Texas, a credulous look becomes a beam of astonishment. This bend in the Guadalupe River, when quiet and limpid, is an artist's delight. The receding hills give you a good chance to show your skill with values in light and shade. I made the original 12 x 16 inches.

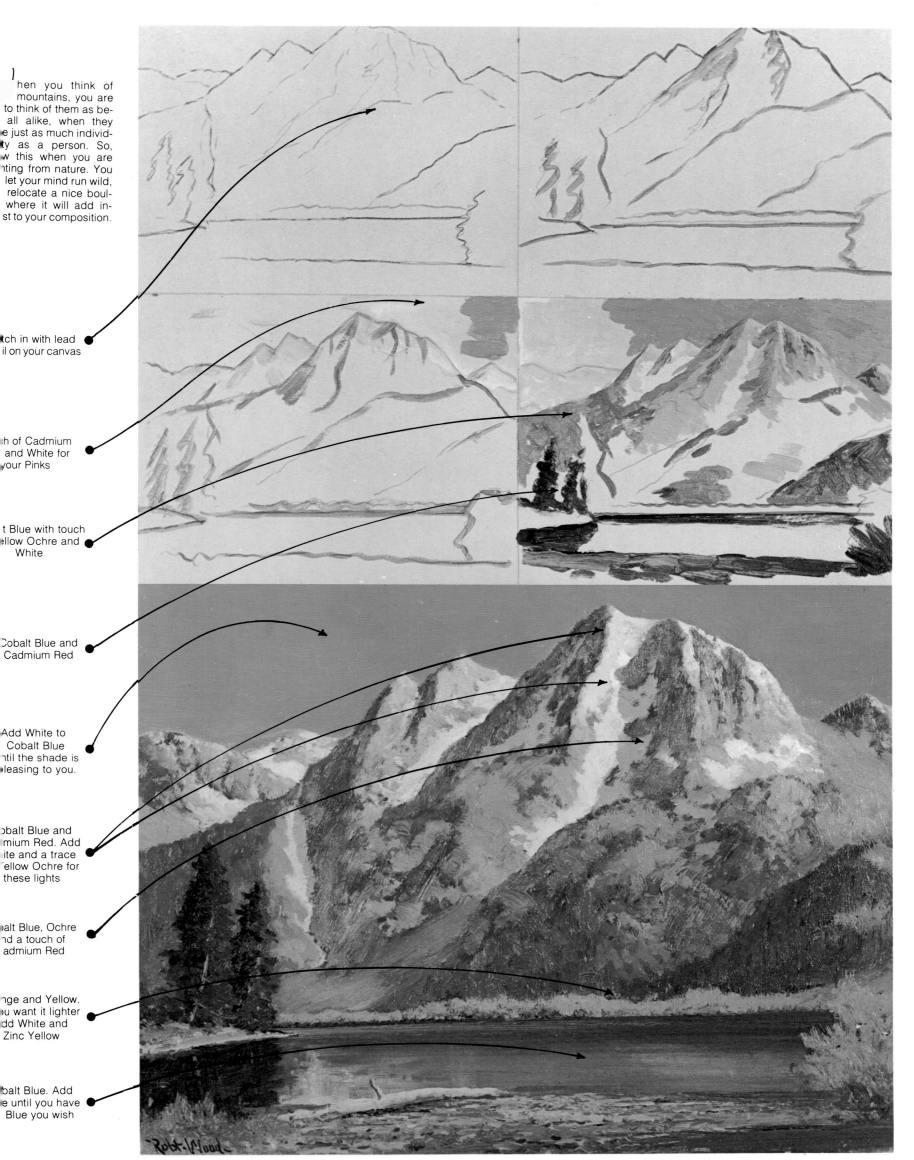

When you think of mountains, you are to think of them as be- all alike, when they are just as much individ- ty as a person. So, w this when you are inting from nature. You let your mind run wild, relocate a nice boul- where it will add in- st to your composition.

tch in with lead il on your canvas

h of Cadmium and White for your Pinks

t Blue with touch ellow Ochre and White

Cobalt Blue and Cadmium Red

Add White to Cobalt Blue ntil the shade is leasing to you.

obalt Blue and mium Red. Add ite and a trace ellow Ochre for these lights

balt Blue, Ochre nd a touch of admium Red

nge and Yellow. ou want it lighter dd White and Zinc Yellow

balt Blue. Add e until you have Blue you wish

CARSON'S PEAK and SILVER LAKE in the SIERRAS

While painting this close beside my car, a young fellow all strapped up with fishing gear appeared from behind those willows. Then, all at once, some trout thrashed around in the water a few feet from his feet. He froze for the moment, unobserved he thought. Soon, he spotted me quietly painting and shouted excitedly, "Boy, did you see that!" I said, "Yes, but you were the sight to behold."

11

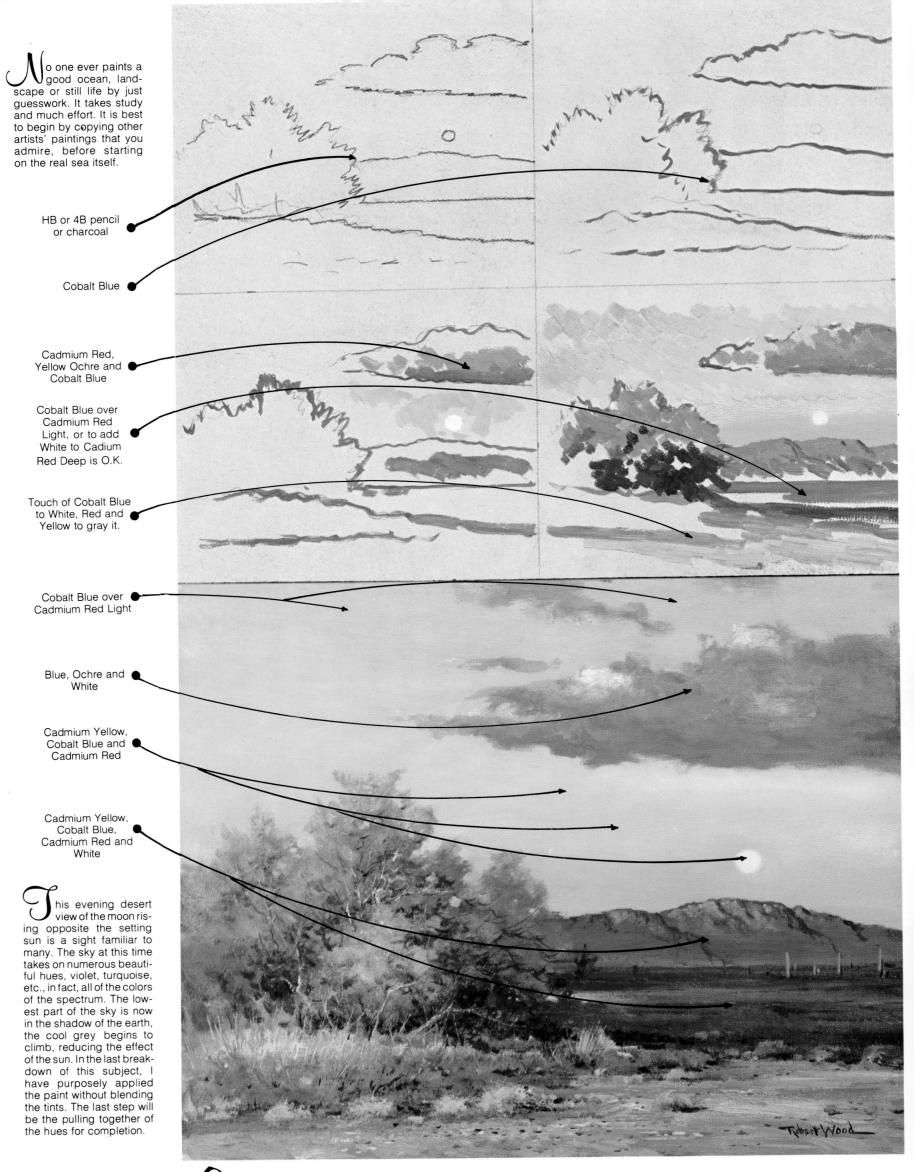

No one ever paints a good ocean, landscape or still life by just guesswork. It takes study and much effort. It is best to begin by copying other artists' paintings that you admire, before starting on the real sea itself.

HB or 4B pencil or charcoal

Cobalt Blue

Cadmium Red, Yellow Ochre and Cobalt Blue

Cobalt Blue over Cadmium Red Light, or to add White to Cadium Red Deep is O.K.

Touch of Cobalt Blue to White, Red and Yellow to gray it.

Cobalt Blue over Cadmium Red Light

Blue, Ochre and White

Cadmium Yellow, Cobalt Blue and Cadmium Red

Cadmium Yellow, Cobalt Blue, Cadmium Red and White

This evening desert view of the moon rising opposite the setting sun is a sight familiar to many. The sky at this time takes on numerous beautiful hues, violet, turquoise, etc., in fact, all of the colors of the spectrum. The lowest part of the sky is now in the shadow of the earth, the cool grey begins to climb, reducing the effect of the sun. In the last breakdown of this subject, I have purposely applied the paint without blending the tints. The last step will be the pulling together of the hues for completion.

Some artists have spent a lifetime studying the ocean, some landscapes, so don't think you can do a masterpiece on your first or second try. I find most people become discouraged if their first painting does not turn out well, and yet, no one expects to play a Chopin Nocturne or a Brahms Cradle Song on their first try. They must spend months practicing scales, etc., before they can play even a simple composition, so please be reasonable with yourself.

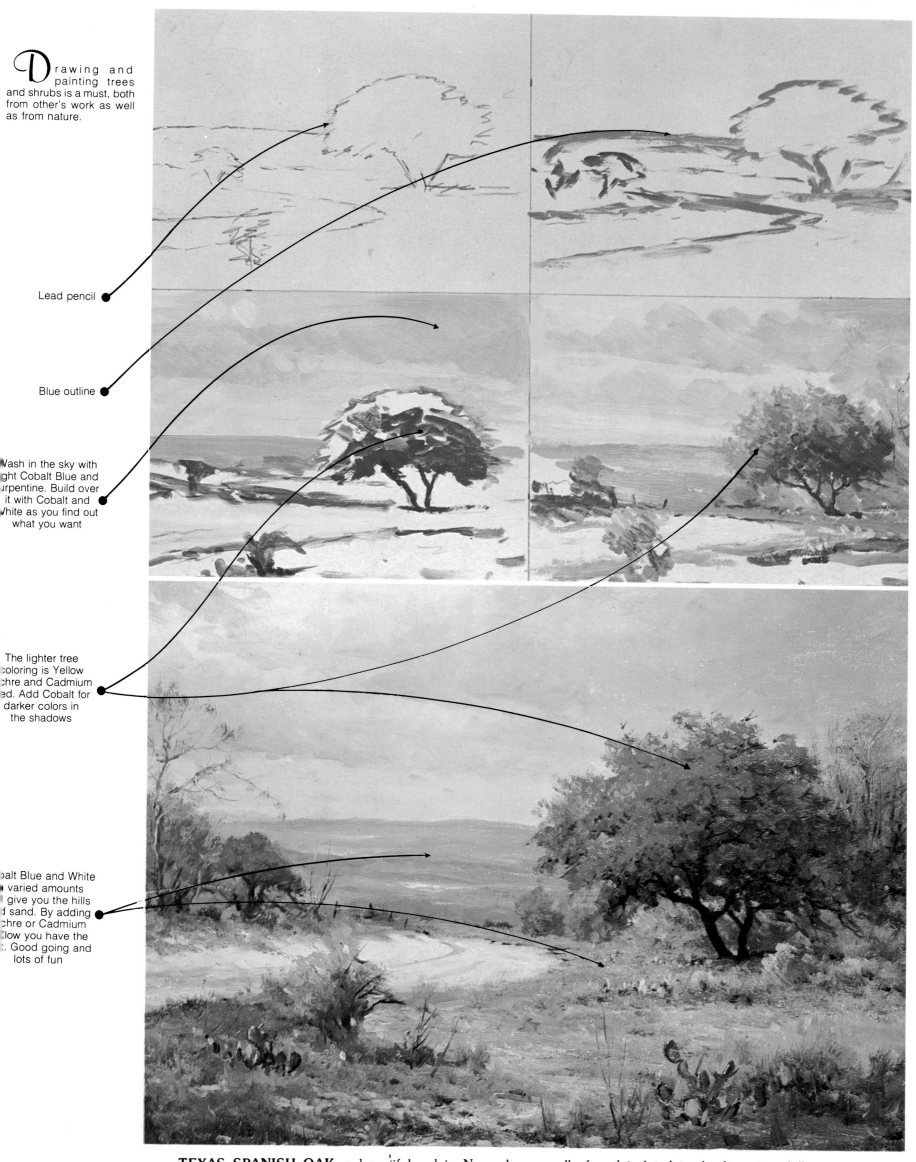

Drawing and painting trees and shrubs is a must, both from other's work as well as from nature.

Lead pencil

Blue outline

Wash in the sky with light Cobalt Blue and turpentine. Build over it with Cobalt and White as you find out what you want

The lighter tree coloring is Yellow Ochre and Cadmium Red. Add Cobalt for darker colors in the shadows

Cobalt Blue and White in varied amounts give you the hills and sand. By adding Ochre or Cadmium Yellow you have the rest. Good going and lots of fun

TEXAS SPANISH OAK, a beautiful red in November, usually found isolated in the limestone hill country among rich green Junipers. The contrasting colors thrill artist and cowhand alike.

While painting on this elevated spot I saw a horseman far off on the middle hill. Very soon he was behind me. Looking down from his saddle he said, "Oh, you all 're paintin'. I thought you might be huntin'. I could see your white shirt from the hills yonder. We don't allow huntin' but paintin' is O.K."

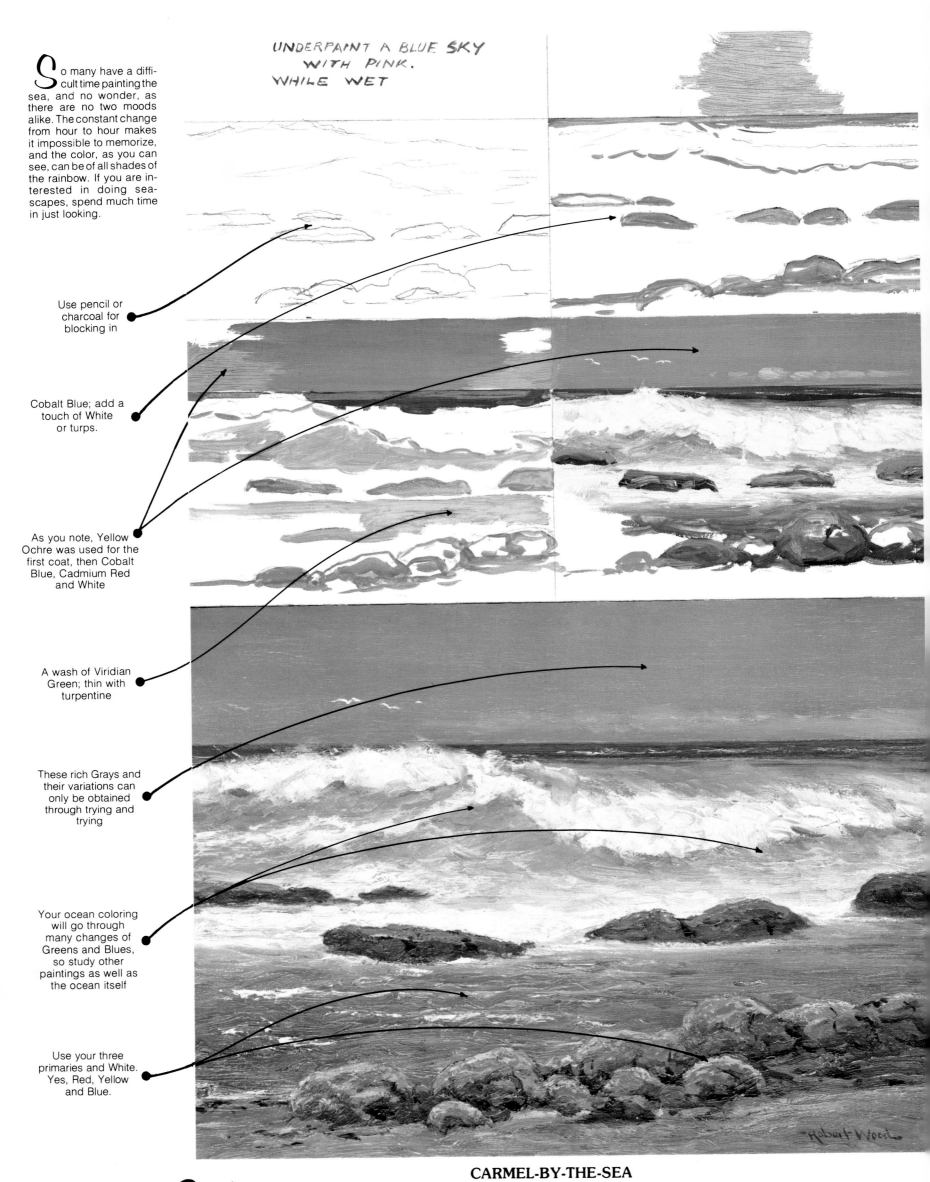

So many have a difficult time painting the sea, and no wonder, as there are no two moods alike. The constant change from hour to hour makes it impossible to memorize, and the color, as you can see, can be of all shades of the rainbow. If you are interested in doing seascapes, spend much time in just looking.

UNDERPAINT A BLUE SKY WITH PINK. WHILE WET

Use pencil or charcoal for blocking in

Cobalt Blue; add a touch of White or turps.

As you note, Yellow Ochre was used for the first coat, then Cobalt Blue, Cadmium Red and White

A wash of Viridian Green; thin with turpentine

These rich Grays and their variations can only be obtained through trying and trying

Your ocean coloring will go through many changes of Greens and Blues, so study other paintings as well as the ocean itself

Use your three primaries and White. Yes, Red, Yellow and Blue.

CARMEL-BY-THE-SEA

What a fascinating place to paint! Those huge, green breakers rolling, that dissipate among the granite boulders on the shore where you are painting, can be quite startling at times. You wonder, "will this one get me"? The very deep blue of the sea at the horizon and also the sky, affords a beautiful contrast to the brilliant green and white foam of the onrushing waves.

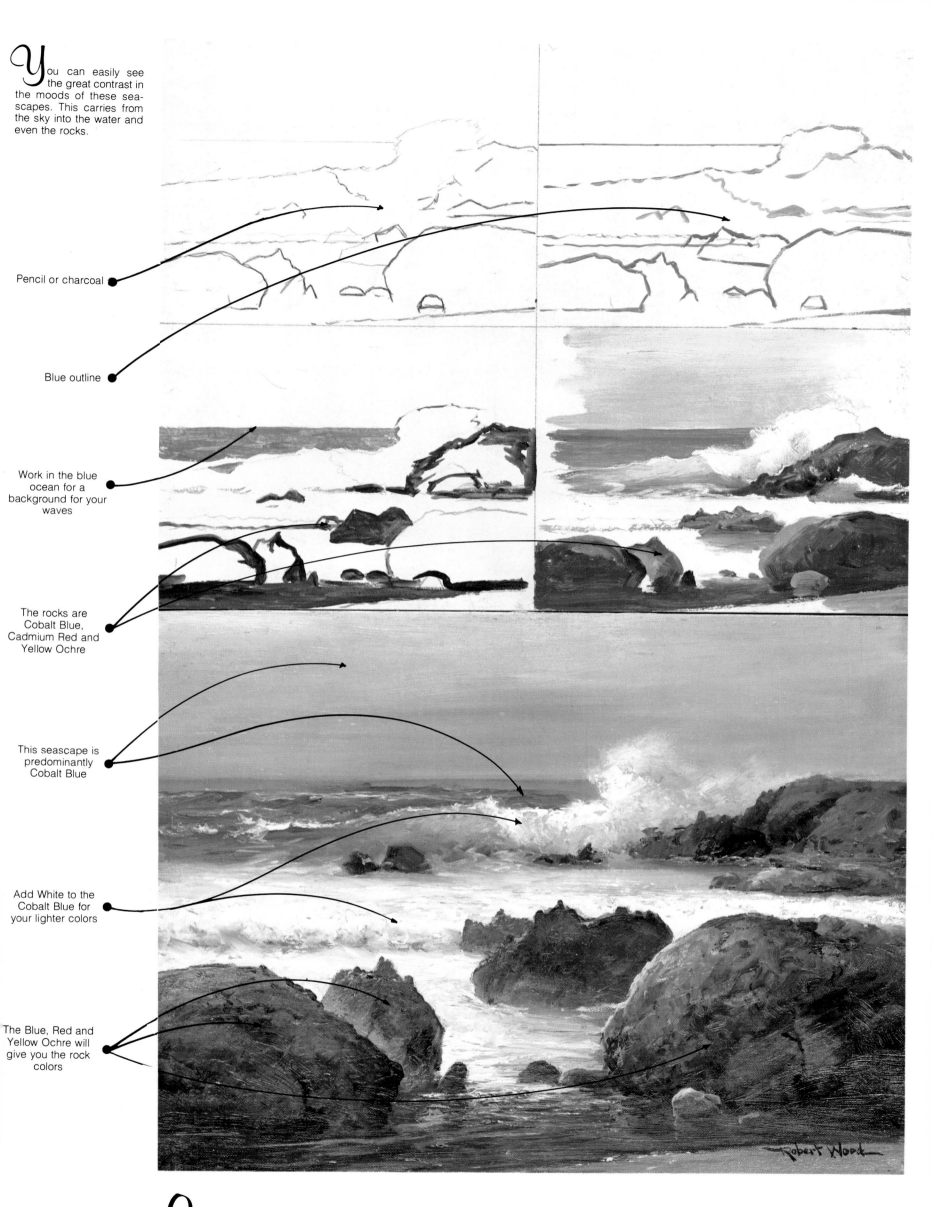

You can easily see the great contrast in the moods of these seascapes. This carries from the sky into the water and even the rocks.

Pencil or charcoal

Blue outline

Work in the blue ocean for a background for your waves

The rocks are Cobalt Blue, Cadmium Red and Yellow Ochre

This seascape is predominantly Cobalt Blue

Add White to the Cobalt Blue for your lighter colors

The Blue, Red and Yellow Ochre will give you the rock colors

Strange as it may seem, you leave Carmel and arrive at our own Laguna Beach, where you will find quite a change in coloring. There isn't as much contrast, and the color in the water is less vivid, yet it is very desirable nonetheless. Rocks here are conglomerate and sandstone.

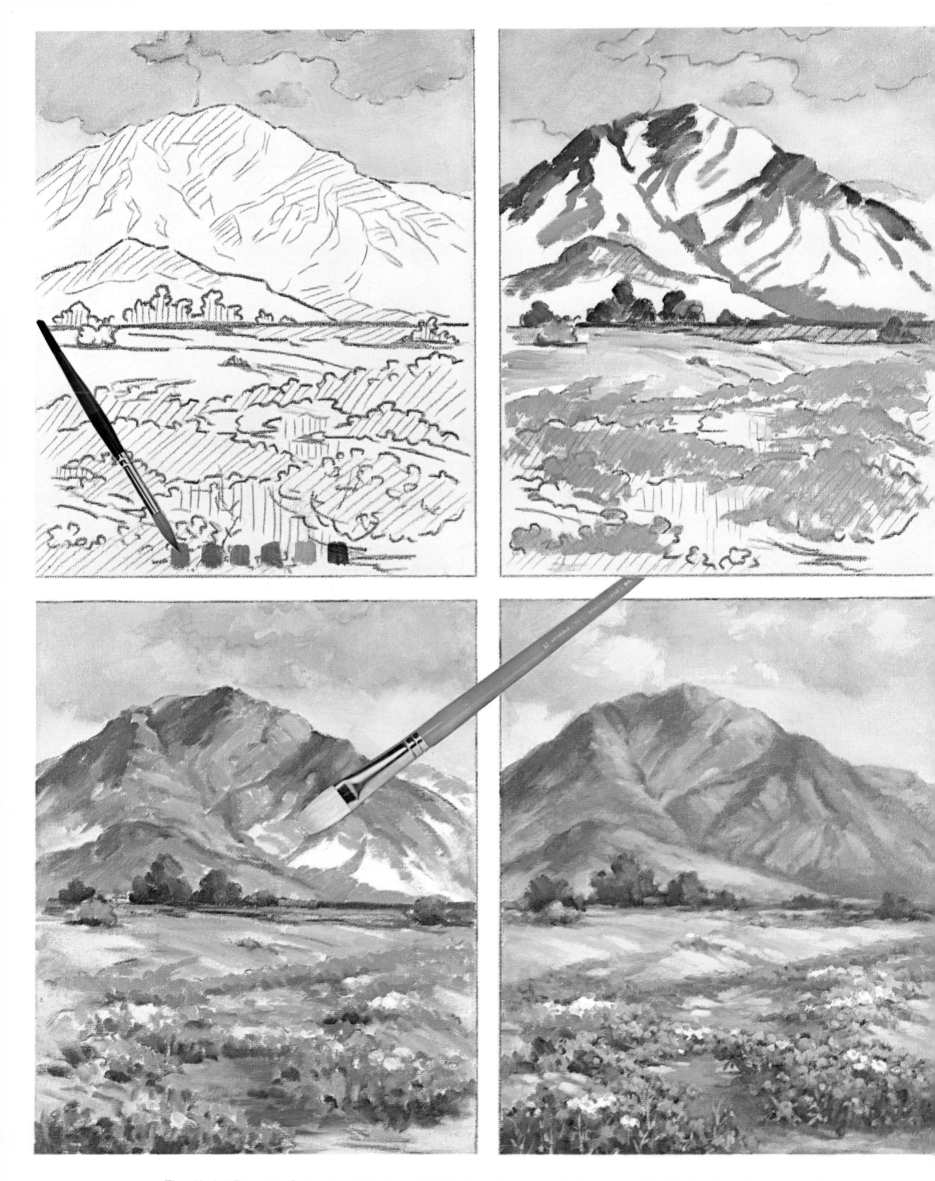

The title is "Desert in Spring" and it is beautiful. Each spring many photographers flock to the desert to capture the beauty of one of nature's lavish spreads—the pinks, blues and purples of the living desert. This picture portrays one such scene.

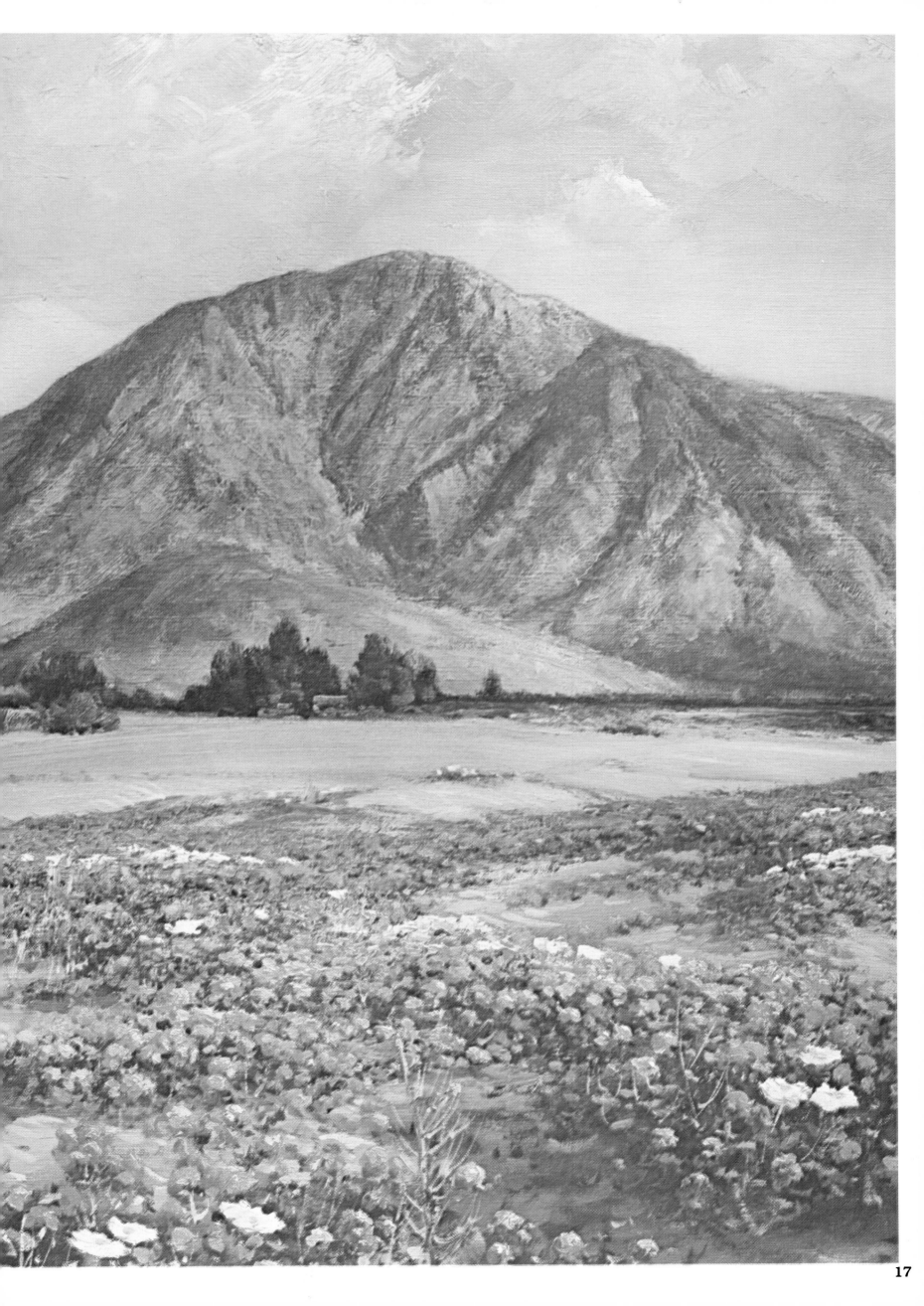

When you have as many vertical lines as with these trees, it is easy to put too much in your picture. They are there to frame and give distance to your mountain, and interest to your picture.

Lead pencil

Blue outline

The sky is Blue and White

Cobalt Blue and add Yellow Ochre to White to lighten

Brown Madder for the darks. Let dry or work in wet Viridian Green

Cobalt Blue and a touch of Red and add White to lighten.

On your rocks add more Red or Sienna to Viridian Green.

This circle pattern of Lake Tahoe and Jeffrey Pines requires careful drawing. Pencil first, then a thin wash painting with Blue, followed by Brown Madder for darks. Finish with heavier paint from your palette. This painting is 12 x 16 in.

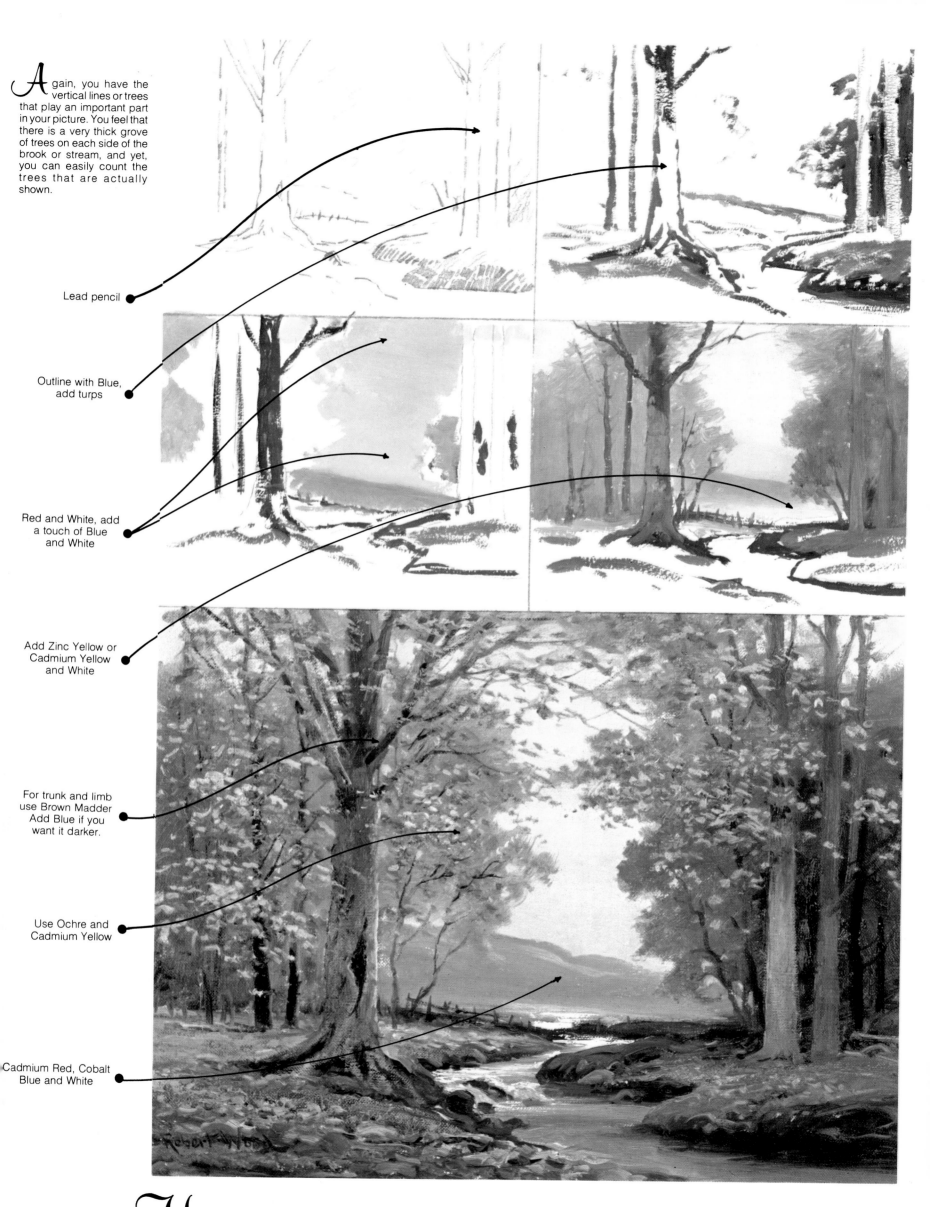

Again, you have the vertical lines or trees that play an important part in your picture. You feel that there is a very thick grove of trees on each side of the brook or stream, and yet, you can easily count the trees that are actually shown.

Lead pencil

Outline with Blue, add turps

Red and White, add a touch of Blue and White

Add Zinc Yellow or Cadmium Yellow and White

For trunk and limb use Brown Madder Add Blue if you want it darker.

Use Ochre and Cadmium Yellow

Cadmium Red, Cobalt Blue and White

Here is an interesting scene located in the Catskill Mountains, somewhat of a circle pattern. Be careful not to split your picture in two. Tie it together with branches and tendrils, or have the creek bank or stream boundary overlap. It is so easy for a painting to become divided—an unhappy situation.

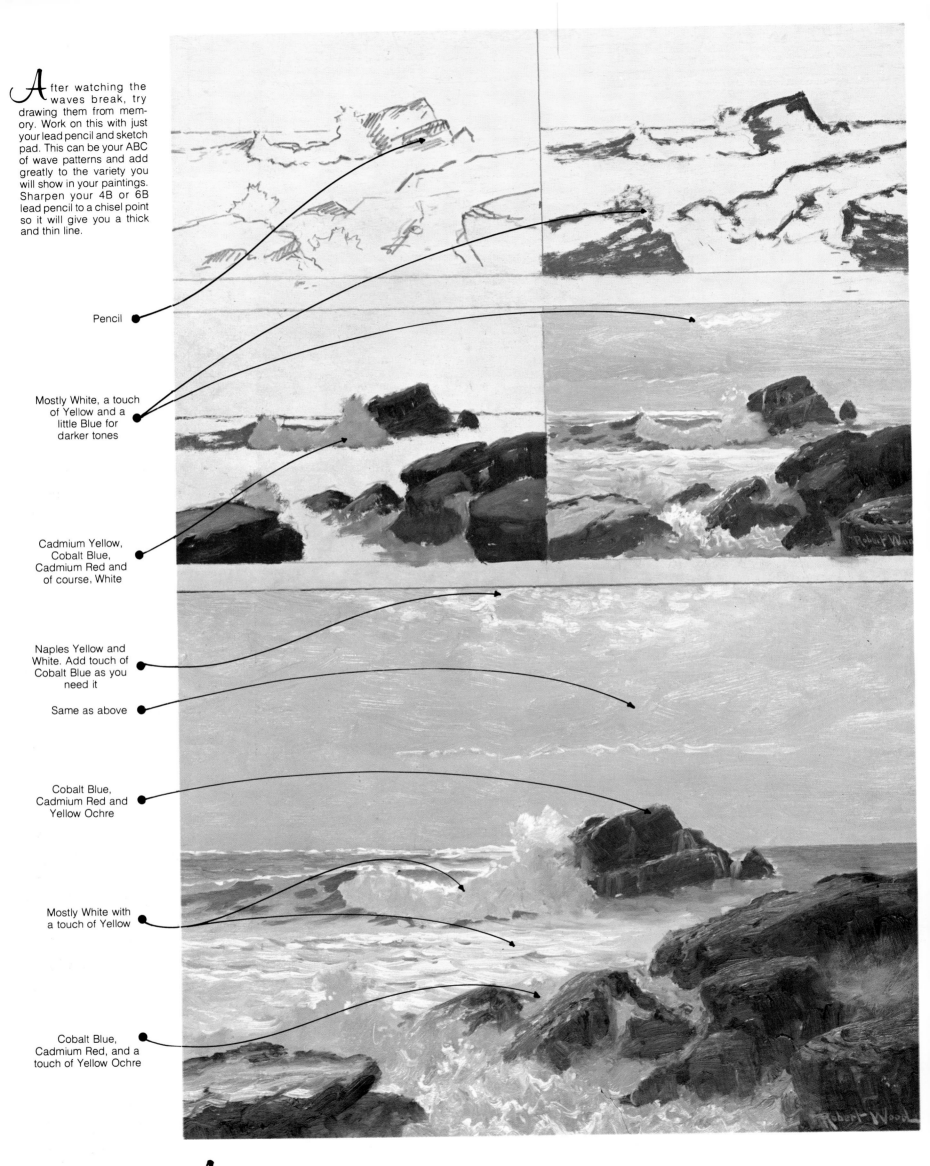

After watching the waves break, try drawing them from memory. Work on this with just your lead pencil and sketch pad. This can be your ABC of wave patterns and add greatly to the variety you will show in your paintings. Sharpen your 4B or 6B lead pencil to a chisel point so it will give you a thick and thin line.

Pencil

Mostly White, a touch of Yellow and a little Blue for darker tones

Cadmium Yellow, Cobalt Blue, Cadmium Red and of course, White

Naples Yellow and White. Add touch of Cobalt Blue as you need it

Same as above

Cobalt Blue, Cadmium Red and Yellow Ochre

Mostly White with a touch of Yellow

Cobalt Blue, Cadmium Red, and a touch of Yellow Ochre

As I live near the ocean, it gives me a chance to study its many moods, and it has so many, one could not capture all of them in a lifetime. The same with sunsets. Make quick color sketches or shoot color shots with your camera to help your memory. Project on a large screen and paint from these.

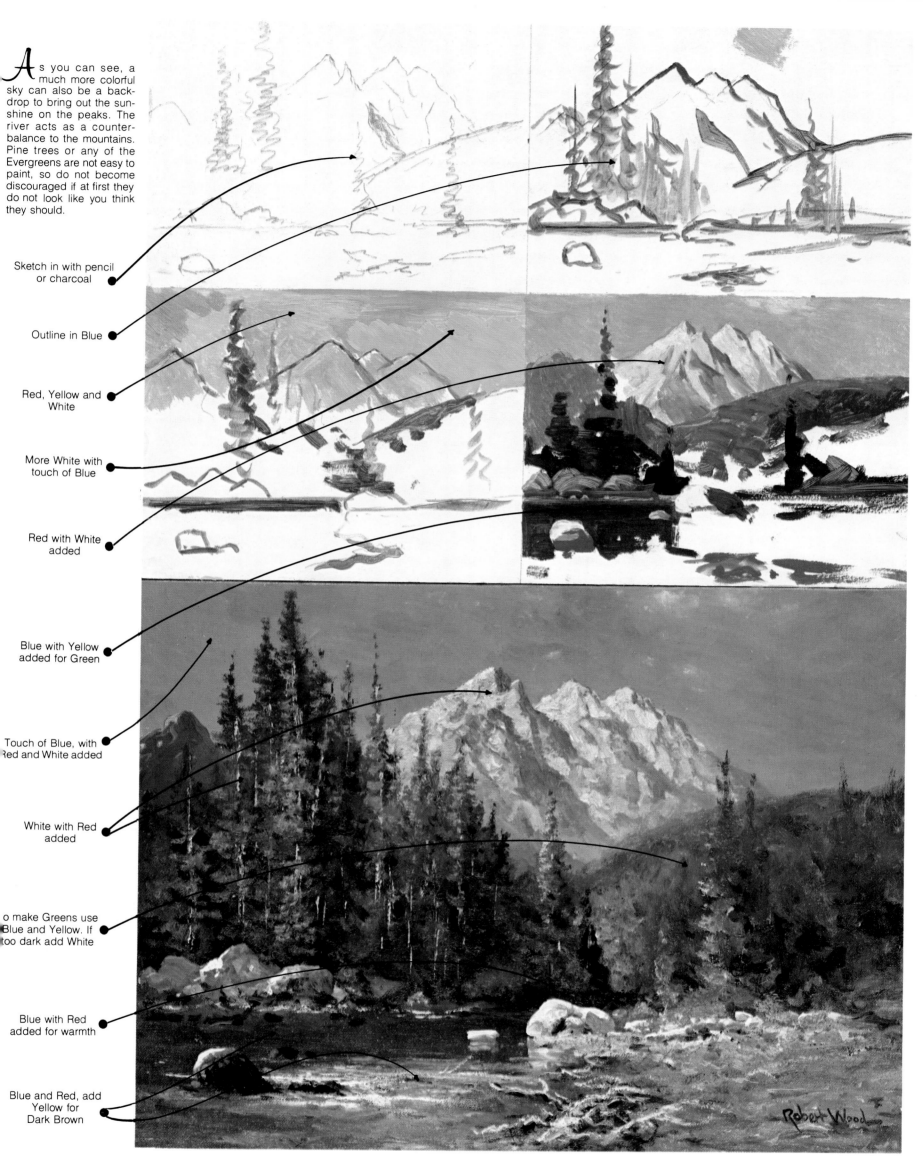

As you can see, a much more colorful sky can also be a backdrop to bring out the sunshine on the peaks. The river acts as a counterbalance to the mountains. Pine trees or any of the Evergreens are not easy to paint, so do not become discouraged if at first they do not look like you think they should.

Sketch in with pencil or charcoal

Outline in Blue

Red, Yellow and White

More White with touch of Blue

Red with White added

Blue with Yellow added for Green

Touch of Blue, with Red and White added

White with Red added

To make Greens use Blue and Yellow. If too dark add White

Blue with Red added for warmth

Blue and Red, add Yellow for Dark Brown

THE MAJESTIC GRAND TETONS

This is the "Cathedral Group," a wonderful subject for the artist. They rise to an elevation of 13,766 ft., more than 7000 ft. above the floor of the Jackson Hole. Together, the Tetons and Jackson Hole form a landscape of matchless grandeur and majesty, unlike any other in Europe or America. This painting is 12 x 16 inches.

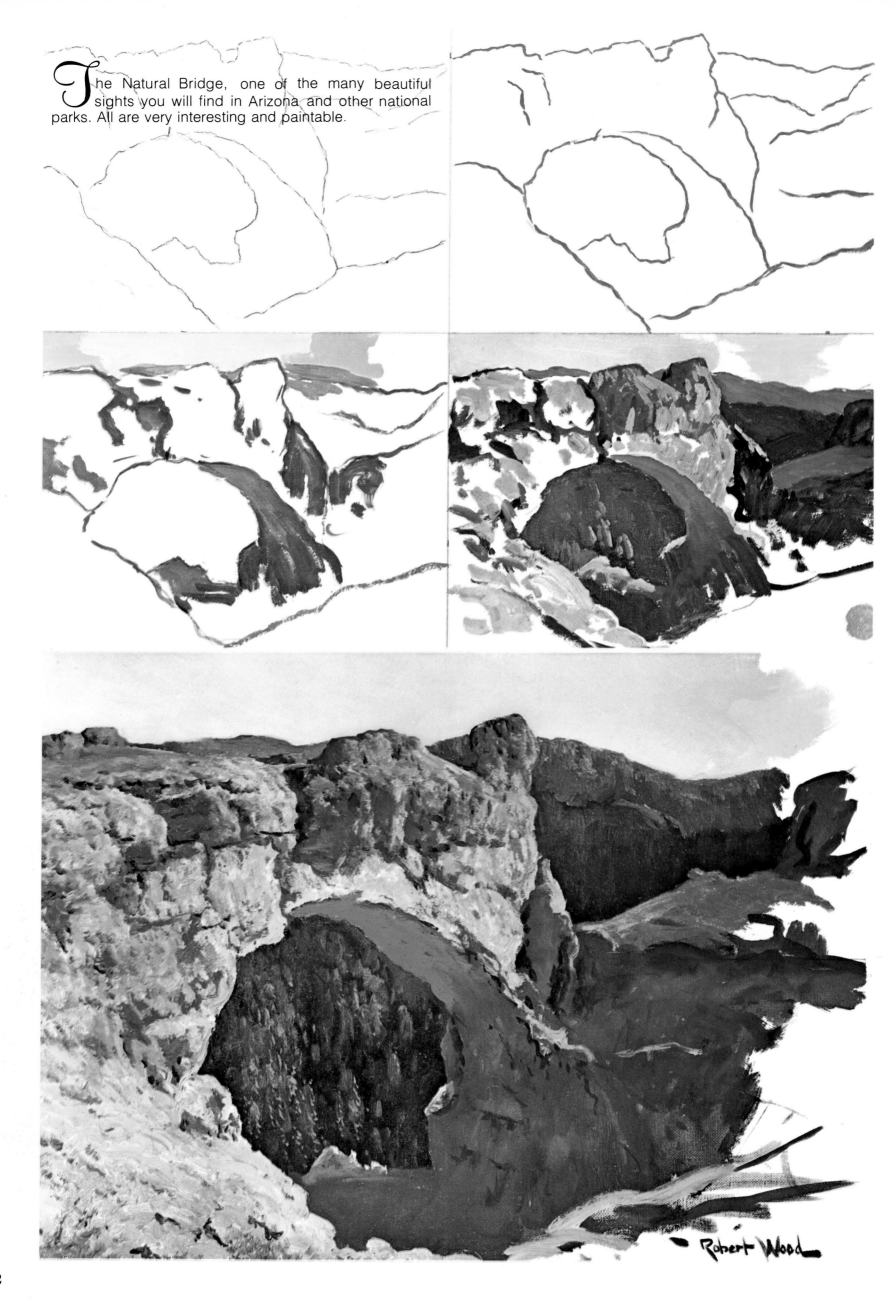

The Natural Bridge, one of the many beautiful sights you will find in Arizona and other national parks. All are very interesting and paintable.

Robert Wood

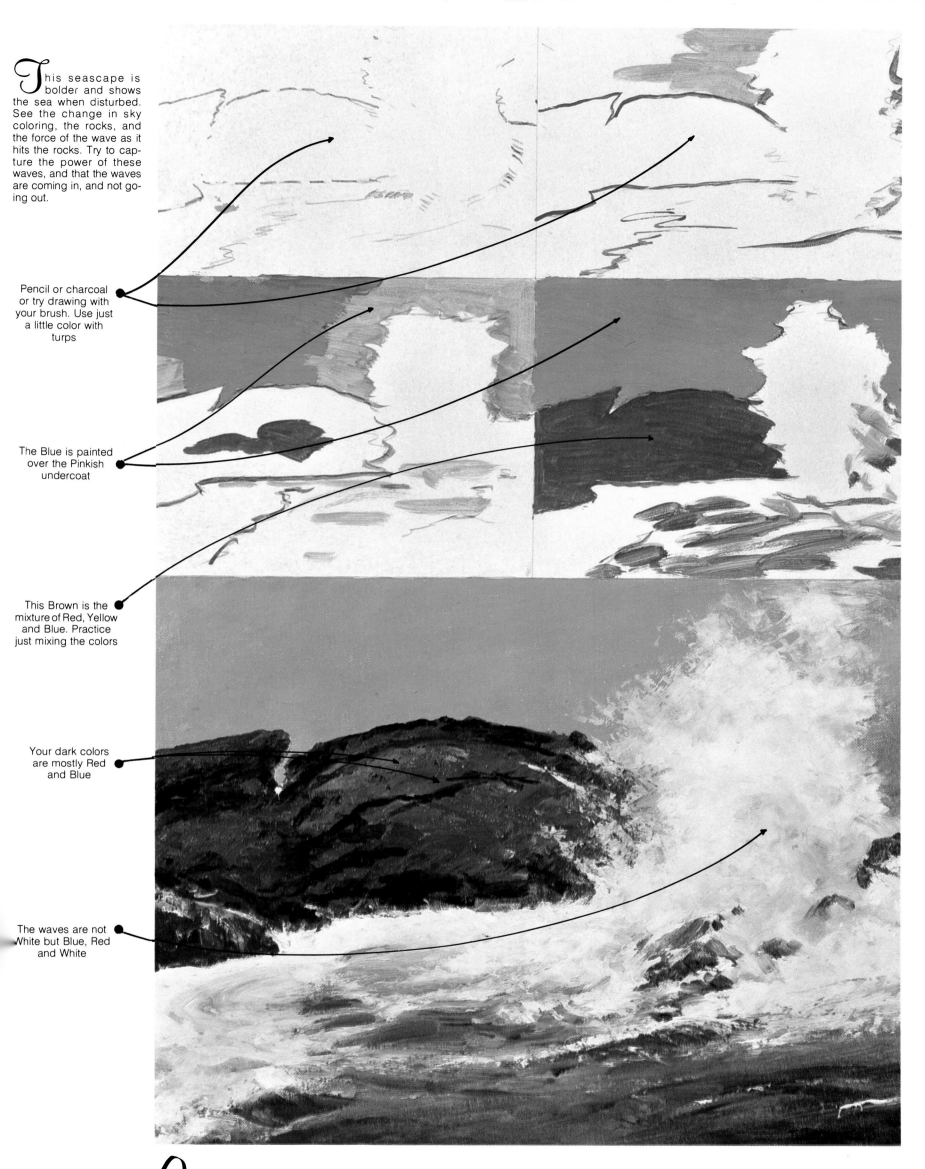

This seascape is bolder and shows the sea when disturbed. See the change in sky coloring, the rocks, and the force of the wave as it hits the rocks. Try to capture the power of these waves, and that the waves are coming in, and not going out.

Pencil or charcoal or try drawing with your brush. Use just a little color with turps

The Blue is painted over the Pinkish undercoat

This Brown is the mixture of Red, Yellow and Blue. Practice just mixing the colors

Your dark colors are mostly Red and Blue

The waves are not White but Blue, Red and White

Commence your painting on canvas by wiping the surface with a mixture of linseed oil and turpentine, half and half. Now proceed as stated on the pages illustrated, first pencil drawing, then a Cobalt Blue outline, finishing with the colors you desire. Thin paintings using linseed oil, will not crack as easily as thick, heavy pigment on canvas. It is not wise to apply paint from the tube on to a dry piece of prepared canvas without first wiping with oil and turps, as mentioned above, assuring cohesion of the tube pigment and the preparation on the canvas. Always use Artists' prepared canvas cotton or linen.

On these two pages I thought it would be interesting to see two of Bob's paintings reversed. Several artists that I have known throughout the years use this method of a looking glass or a hand mirror to reverse their paintings for a different composition, or so they can see their mistakes.

These two paintings were a pleasant surprise to Mary in the camera room when she shot them for reproduction. Try the one you like best and change what you wish.

W.T.F.

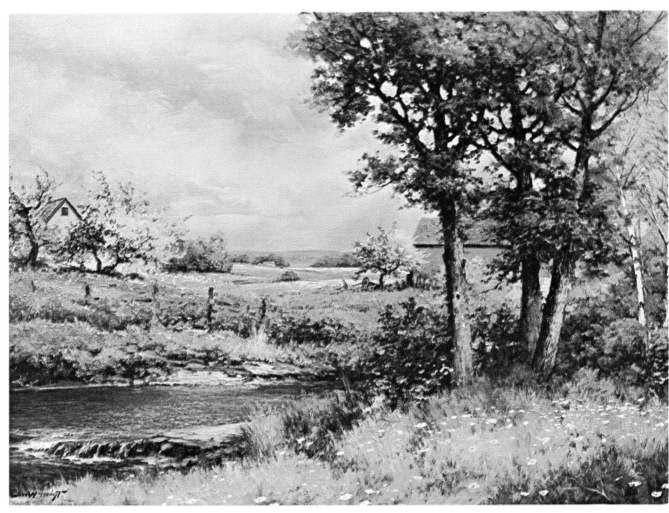

SPRINGTIME

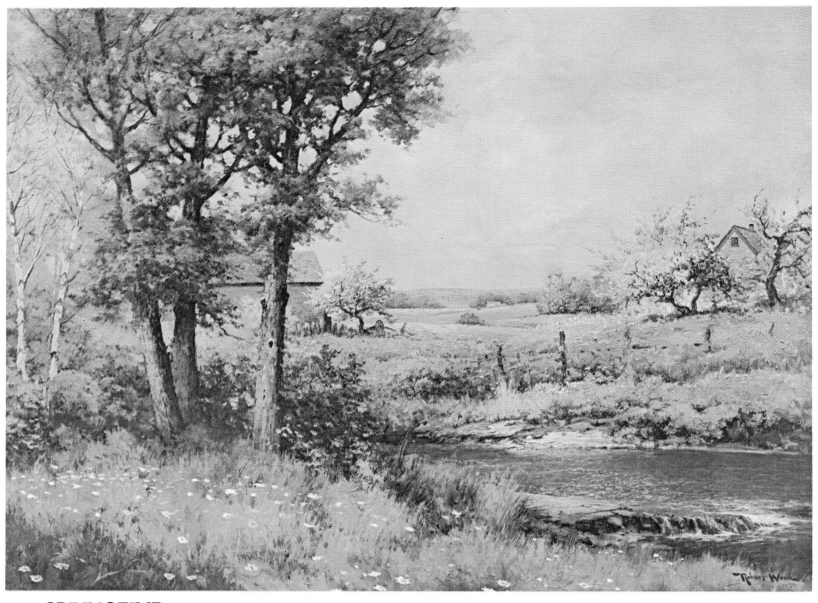

SPRINGTIME

A utumn is one of the most delightful seasons to drive through the country in any part of the world, especially where the nights are cold enough to turn the color of the leaves. Next best is spring, when new life starts in the forests and animals and birds come alive again.

To work out your own composition, move trees or rocks from another painting. You will learn to create your own pictures this way. No matter whose paintings you copy, there will be some of yourself in it. But, the more you try for yourself, the more it will be your own style and individuality. Good going!

W.T.F.

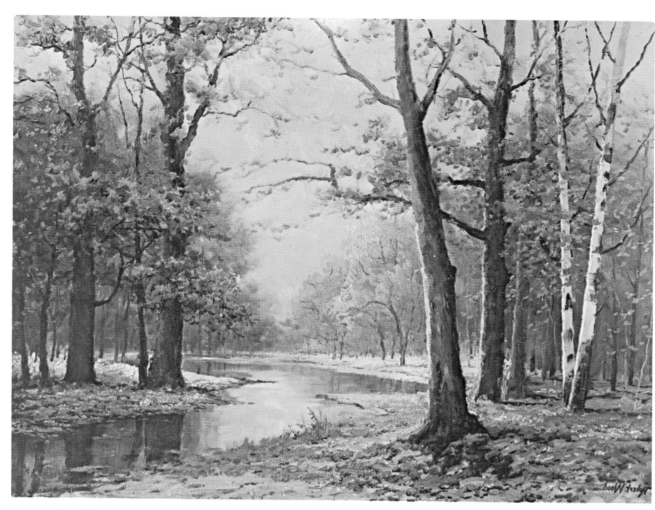

AUTUMN GLADE

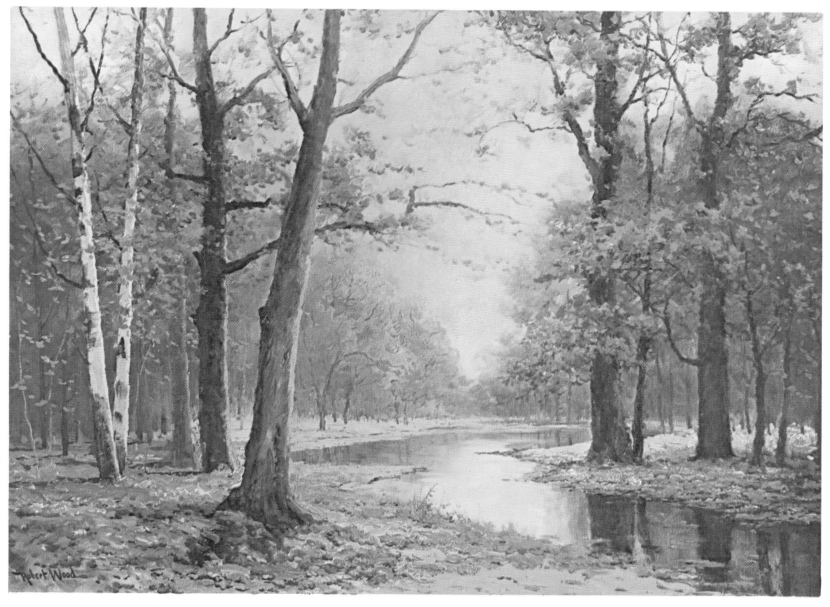

AUTUMN GLADE

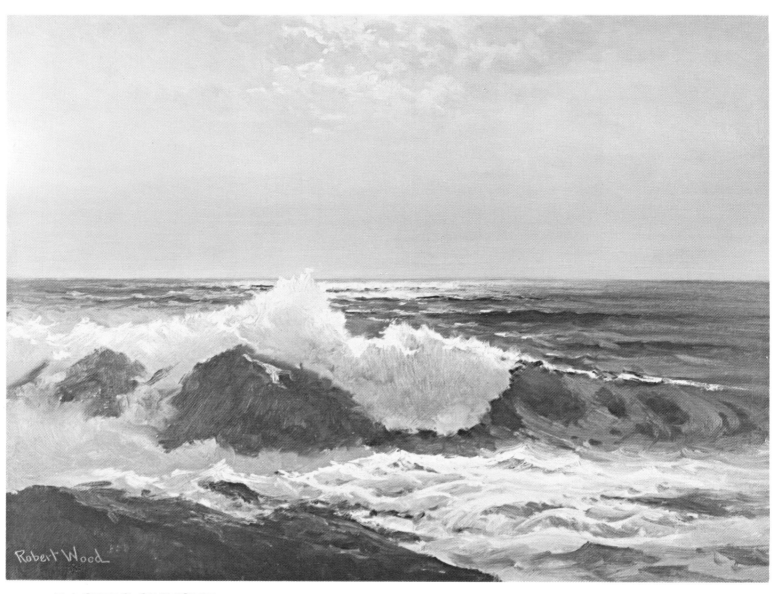

PACIFIC SUNSET

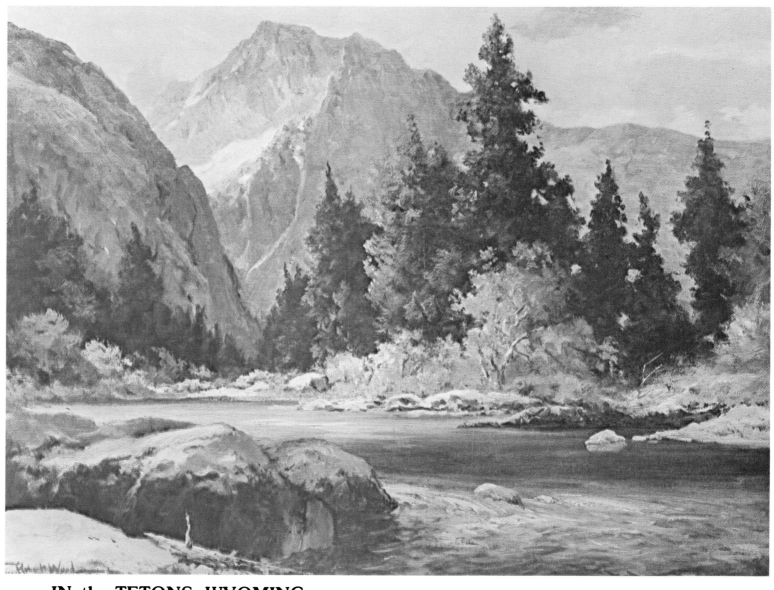

IN the TETONS, WYOMING

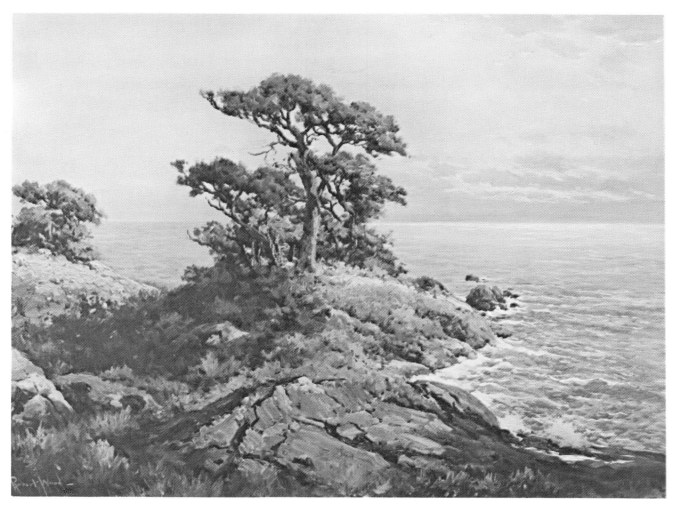

This well-known spot in Carmel is a great favorite of so many artists. If you are in the vicinity, do take the Seventeen Mile Drive. You will see a great variety of seascapes such as the one below.

As Bob explains in the beginning of his book, study the waves, and remember, the first dozen trips may be a disappointment to you but keep trying. It is all of those failures or mistakes that add up to a successful painting.

PACIFIC COAST

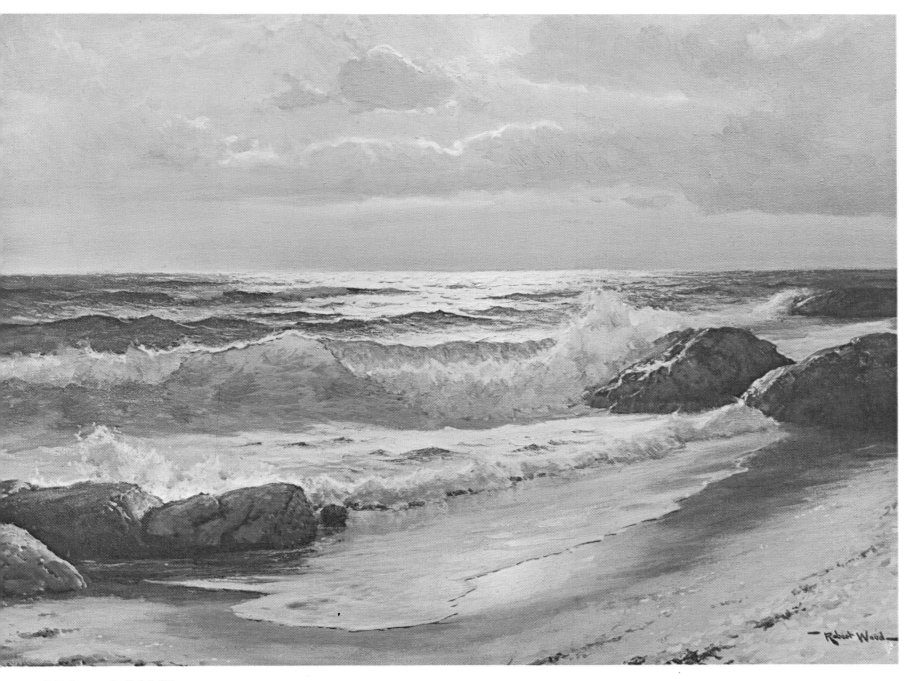

SEA and SAND

27

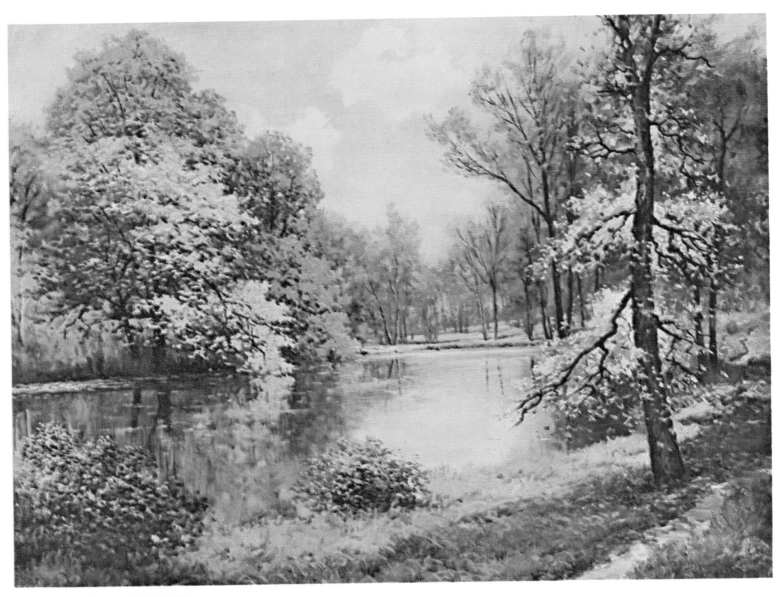

PATH of GOLD

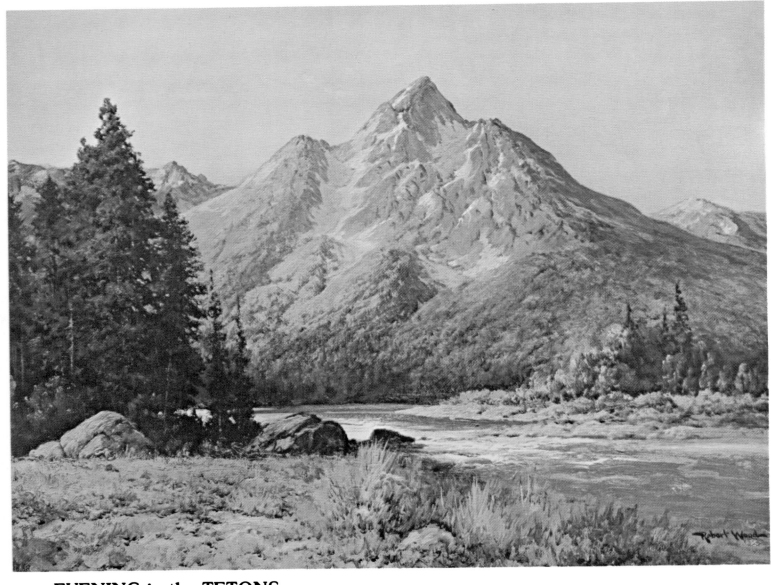

EVENING in the TETONS

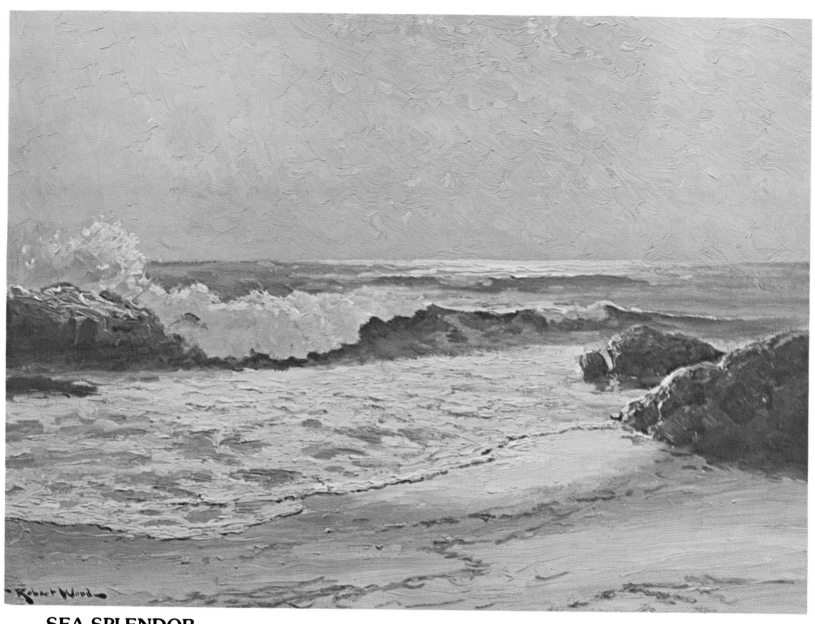

SEA SPLENDOR

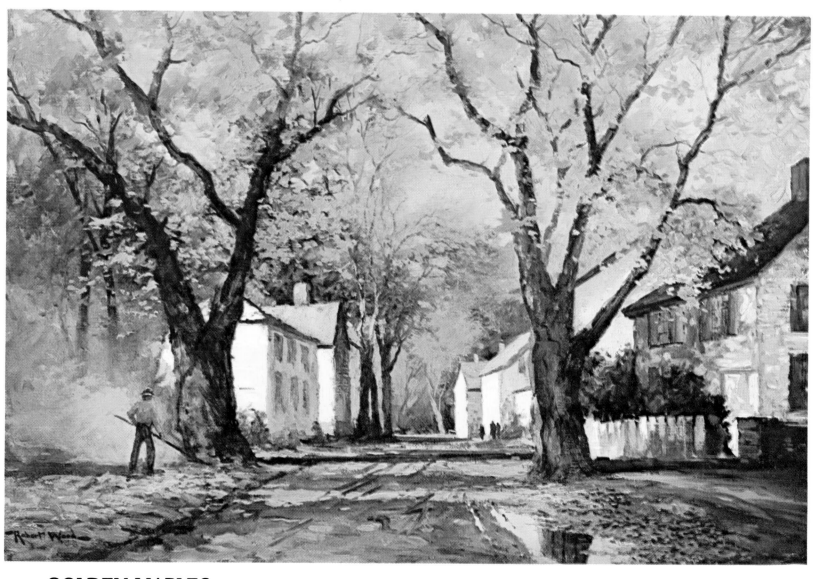

GOLDEN MAPLES

When I asked Bob to tell just how he proceeds in making a painting, he said, "I can show you in pictures but not in words—you write what you want, Walt." So, here I am again. As you can see, Mr. Wood has made the trees to the left the center of interest and if you were to divide the picture space into thirds, you would find the tree on the one-third line.

Draw in the first step with pencil or brush. The more you know about the subject the less you have to draw, but do not be too sparing at the start.

This painting has an "S" curve to the brook which leads your eye into the distance. Notice the brush strokes in the rather heavy texture of the sky. The leaves on the trees are carefully placed spots of color. You may have to experiment awhile to get this effect. Practice a lot until you are satisfied with your picture.

This is a very easy step-painting to follow of a most interesting, but difficult, painting to do. It has just about everything in it that should be studied part by part. Take a whirl at it, as it is most fascinating to do. You can always paint it out if it doesn't please you.

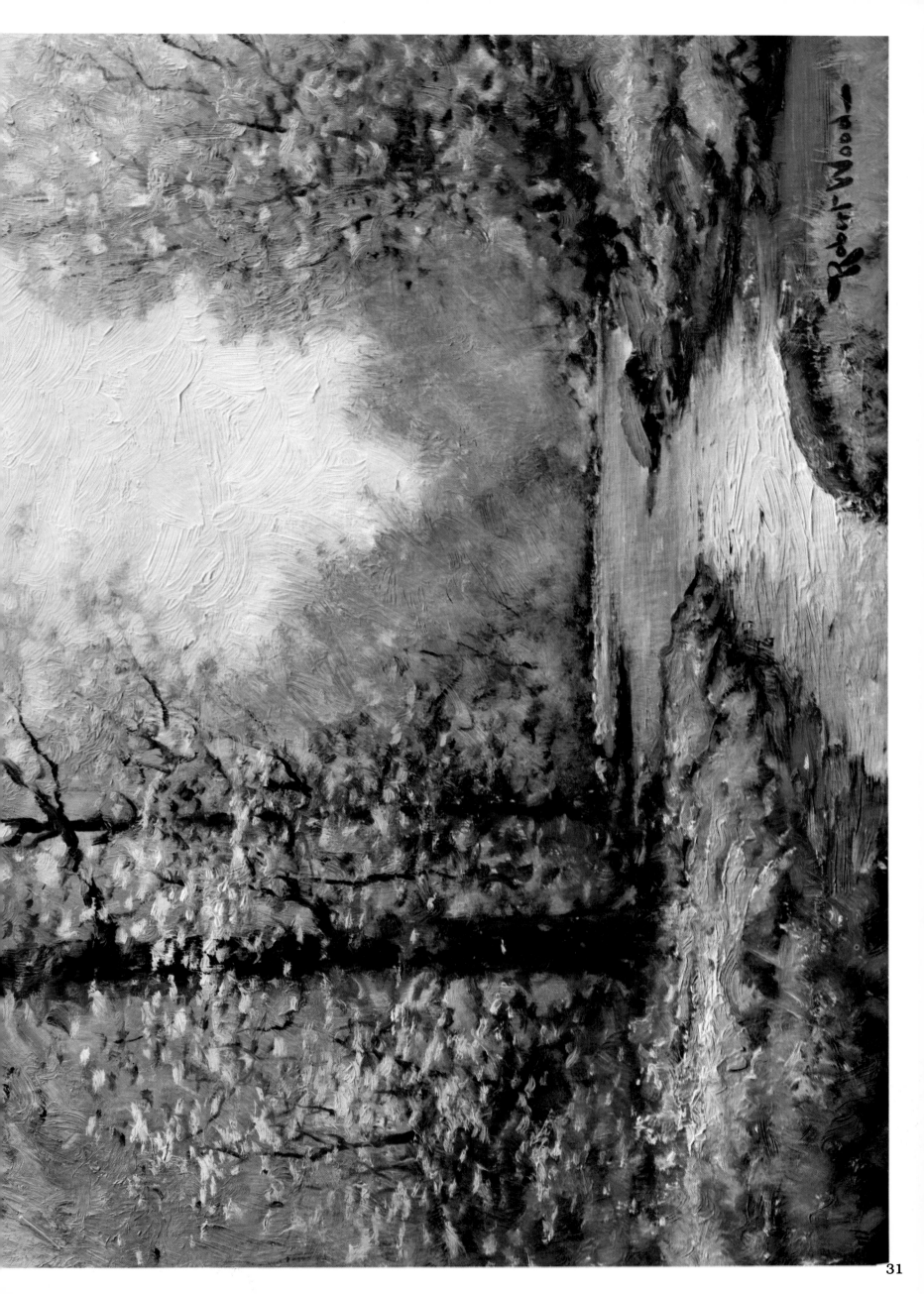